WRITER'S RESOURCE: Character Building

Jamais Jochim

Copyright 2019 Jamais Jochim
All rights reserved.
No appearance on this pages should be seen as a
challenge to any existing trademarks.

TABLE OF CONTENTS

5 CHARACTERS CAN BE A PROBLEM

7 IN GENERAL
7 Starting With The Plot
9 Character versus Plot
11 A Quicky Character Build System
13 The Importance of Non-Character Characters
15 Problem Characters and How To Deal With Them
17 Being Diverse Just For The Sake of Being Diverse
19 Using Something From Mythology
21 A Quick Checklist of Do's and Don't's
24 Top Ten Cliches to Avoid

35 HEROES AND VILLAINS
35 Avoiding Mary Sues
37 Could Your Character Survive The Bar?
39 How A Villian Should Work
42 Why Your Heroes and Villains Need Organizations

45 EVERYONE ELSE
45 Why You Need Extras
47 Using Extras To Effect

49 The Importance of a Good Pit Crew
51 Who Is In Your Pit Crew
56 The Importance of a Good Sidekick
58 Having Fun Abusing the Sidekick
60 Some Notes On The Romantic Lead
63 How Not To Refrigerate Women
65 The Pragmatism of Organizations
67 What the Support of an Organization Will Get You
69 Sinister Organizations Are So Much Fun

71 COSTUMES
71 Basic Considerations of Costume Design
74 What Is It Made Of?
76 Form versus Function
77 Spandex versus Armor
79 The Perennial Debate of A Good Uniform
82 Fun With Tattoos
83 Dressing Women is Harder Than It Looks
87 Weapon Design 101

91 CONCLUSION

CHARACTERS CAN BE A PROBLEM

Far too many creators have a problem with characters. Too many of the characters are one note, share far too many similarities, or are just doing too much. The solutions are pretty easy: The writer needs to develop their backgrounds, there needs to be better differentiation between characters, and characters need to have their roles better defined. However, a lot of writers have issues doing so, and that's a shame: It's not as hard as it may look at first blush.

Making it worse is that too many creators are trying to create an iconic character. Rather than just making a character that works for their project, they are trying to write a character that will become famous and catapult them and the comic into fame along with it. You can't just do that, however; such a character requires being in the right time at the right place in the zeitgeist and that almost never happens.

So here's the deal: I can show you how to fix a lot of the character problems you're having and how to create a classic character. It just requires re-thinking your approach on characters and going deeper into character development than you have before; that I can show you. This entire book is all about weird approaches to character design and solid ways to create some great characters. By the time you finish this book you will have all sorts of ideas for how to do characters and how to even have fun with the character design process.

6 Jochim-Character Building

So while I may not show you how to create that once-in-a-lifetime character that will catapult you into a new level of fame and glory, you will be creating much more solid characters that have been better integrated into their universes, and that should more than satisfy you.

IN GENERAL

There are a lot of considerations when it comes to creating characters. The bottom line is that these are people that you will hopefully be spending a lot of time with, and so it can only help to put a lot of work on them. While the majority of the characters you will deal with will be little more than just quick sketches there are some that you will be putting a lot of work into. As such this book may help you deal with most of the problems that come up during character generation. Just remember to have fun with it and it should be relatively painless. Honest!

Starting With The Plot

It may sound weird but you need to develop plot before characters. It's just easier to make characters when you know where they will fit.

Think about that for a moment. When you create the characters first, you are stuck with the characters that you have created. You'll almost feel guilty about throwing a character out. If you find that you don't need a character, you'll try to write that character in, no matter what damage you do to the plot. On the other hand, if you wait until the plot has been developed, you'll know exactly what characters you need, which makes designing them a bit easier: Rather than fitting the plot around the characters you can fit the characters into the plot.

8 Jochim-Character Building

Another consideration is that by looking at the plot, you'll see some characters jump out at you as needed that you hadn't considered. Even better, you'll be able to see where you need minor characters that you didn't think about when designing the characters in the first place. This means that your characters will also be better grounded in the reality of world as they were created to fill specific niches.

By setting up the plot, you've also decided how dark or light the story will be, and your characters can be designed accordingly. And, since your plot only dictates the basics of the characters, you can design full backstories for them. Had you designed the characters first, then you would have been meshing in all sorts of strange backgrounds without much care how they really connected. That is, you already know how the characters link and what kind of histories they need before you even start; a lot of the homework has already been done.

Oh, and don't be stuck by some silly arbitrary number when you create characters. It's easy to say that you need X characters per Y pages; that's hogwash. Just realize that there is a balance that needs to be struck: The fewer characters you have, the more you can explore their backgrounds, but they also need to be far more capable (after all, they'll be needing to do more). On the other hand, if you have a larger cast, you may not be able to explore their backgrounds as much, but you can also have more fun, you don't need to worry about consistency as much, and you don't need massively able characters (which means that the combats won't last as long).

Keep in mind that you can always change the plot; it's hardly immutable. However, the plot gives you an excellent skeleton on which to place your story. If you decide that a minor character would be fun to have a romance with, or otherwise need to give

him more lines, so to speak, go ahead; plug into the plot and see what happens. If nothing else, the romance can either end up helping later on, thus bridging a potential plot gap, or add a more organic feel to the comic.

In short, by doing the plot first you save yourself some grief later on. And that can be a great thing when you have some world-spanning epic you are debating…

Character versus Plot

There are two schools of thought on what is more important, plot or character; you need to decide before plotting which school you like.

The character-first school believes that character is important because it's the choices of the characters that define the story. The major advantage is that avoids "Acting Appropriately Stupid", that requirement where the only way to further the plot is if a character or three makes a stupid decision that is against their character (such as splitting up and taking showers while the psycho killer is a known factor or ignoring their intuition which has served them well). However, sometimes the writer gets into plumbing character depth but usually at the cost of a coherent story; the plumbing gets so deep that the story is ignored in order to better explore the characters.

Admittedly, I'm for anything that avoids the AAS issue, but the character-first story has a problem with it: Little actually happens. The writer usually gets so wrapped up in the characters that he is afraid to affect the character long-term; the characters are considered sacrosanct, and is thus not allowed to change. After all, if what the writer likes about the character changes, then it's no longer the same character and will no longer be as

fun to play with. However, a static character is only so fun to read in the long term; people want to see some change in the character over the long term.

Worse, it becomes harder to avoid the Mary Sue problem (a "Mary Sue" is a character, usually female (males are "Gary Stu") that is perfect in every way, and has abilities that far outstrip any competition, and has a "destiny", but has some dark history that or desire that is counter to her plans). Instead of a realistic character development, the writer develops the character's abilities rather than her personality further alienating the reader as he can no longer relate to the character. It just hits the point that she has a large number of abilities but no real personality.

By going with the plot-first approach, the character is forced to change, and in a realistic way. Also, the characters won't drag the story down, as you won't explore the side trips; you'll focus on the plot, and that's a good thing. Your characters will also change as they adapt to the plot, and react to it realistically. Also, it allows you kill characters and not feel guilty about it. By making the plot more important than the characters, you can also throw stuff at the characters and see how they react to it.

However, there is the danger of making the plot so important that the characters are forced to make decisions that they wouldn't normally make in order to keep the plot going. Also, you start seeing coincidences start piling up as the plot barrels on regardless of the desires of the characters. While this is great for absurdist comedies it's not so great for anything else and risks alienating readers as they have to suspend disbelief at every new plot twist. This just means that you need to keep an eye on the plot and prune it when it starts getting out of hand.

Either way you can explore the characters' characters in ways that also move the plot along, allowing you to have fun with your characters. As long as you can avoid the AAS syndrome, you can actually do what you want (explore the characters), while doing what you story needs (the plot). By reaching that compromise, you can build a stronger plot, and have fun doing it!

A Quicky Character Build System

When it comes to your characters, you should have a basic build system. For those that role-play, you know what I'm referring to; it's how you create characters. For those that don't do much role-playing, it's a system that allows you build characters quickly making it ideal for writers who need to populate a world quickly with fully-rounded characters. There's a simple system for building characters that makes it simple to set up as many characters as you need in very short order. Oh, but you will need a pencil, a sharpener, and a lot of index cards.

The first step is to determine what role the character will be playing in the story. You can be as simplistic as hero, villain, sidekick, or bystander, for example, or work the character into the theme ("the character shows the hero that there is always hope", for example). The more specific you can get the better, as the more specific you are at this stage, the simpler the other stages will be. It's important that you know what role the character will play; even if it amounts to a cameo, the character needs to do something or you're just wasting words, and every one of your words should be well-chosen.

Once you have established what the character's role is, you can then assign a power level. Even in stories where magic and superpowers aren't used, characters tend to have power levels defined in terms of the story; in a military story, for example,

rank, experience, and access to weapons and vehicles would define power. In a high school setting, social status, skill sets, and grade level would be determined by power level (a senior with impressive hacking or athletic skills who is capable of asking anyone for favors would have a higher power level than a freshmen with no contacts, little status, and few skills, for example).

You should limit the number of god-like characters, however. If you have a lot of them running around, it quickly becomes a question of either why they don't take care of the problem, or why characters would want to know everything when they can't use that power. Tolkien had the right idea; the important action was in the background with Frodo, and the power characters had to deal with the major problems. Even Tom Bombadil was used to effect, even with his limitations of where he could go.

Even if the setting is exploring extreme powers, you need to keep in mind that the characters should not be the most powerful beings in the story. Even Superman and The Authority are not the most powerful beings in their respective comics; there are still entities that are more powerful than them. It's not a balance issue; it's more that, if they were the most powerful entities, there would be no challenges for them, and they wouldn't be as interesting. They would walk through any challenge and you would hard-pressed to come up with an interesting adversary for them, and without an interesting adversary your story would be boring before you even got out of the gate.

You should then determine the character's personality; combined with the power level and role, the personality will determine appearance, abilities, and other basic characteristics. You should define three personality traits, two good and one bad. That should give your character a balanced, three-dimensional personality.

While you're at it, go ahead and give the character two to four advantages, things that he does that he does better than other characters, and that allows him to stand out. Also, define one or two negative qualities. Being an apprentice bears special noting, especially given the number of sidekicks and young heroes; an apprentice should be considered a negative attribute as the character has to (at least theoretically) obey his master.

And that's my quicky character generation process. All other features should be easy to define; the broad strokes have been painted in, and you should just need worry about details. Admittedly I prefer to use an actual table-top game, such as the Champions RPG, so I have a full range of stats, but that's me. But this should be more than enough to start. Hope this helps!), while doing what you story needs (the plot). By reaching that compromise, you can build a stronger plot, and have fun doing it!

The Importance of Non-Character Characters

You need to realize that the word "characters" covers a lot of evils. Not only does it cover the main characters (heroes and villains), but it also covers their respective minions, as well as a number of plot devices and window dressing. It also covers a lot of other things as well. Let's take a long look at characters, and what they really are, and let's ignore the obvious ones.

"Window dressing" characters are your basic extras. They're necessary because they help make your world feel inhabited. A lot of comics forget about them, either because they're too complicated to draw, and so figure out ways to not have to draw them, such as keeping the strip inside or in isolated places. Admittedly, this is more of an artistic consideration than a writing one, but it's something that needs to be considered. After all, it's sorta like going into a forest and not hearing anything; it's sort of creepy.

14 Jochim-Character Building

It may seem weird to think of a "plot device" as a character, but this is exactly how "deus ex mechina" characters work. Consider Galactus from Marvel Comics; any time that The World Devourer shows up, it's for an important reason. He has put Phoenix on the right path, gotten the Fantastic Four in trouble with the Galactic Council, and ended wars. In short, his appearance moves the plot forward, or helps it conclude. Admittedly, this applies to most of Marvel's cosmic entities, but it applies to any character with a large amount of power that needs to stay in the shadows for most of the comic. These characters don't need to be fully fleshed out as they are there just to get the plot back on course and/or wrap things up.

And then there are those characters that aren't characters. The environment itself can be a character; horror comics and any comic set on the ocean would do well to remember that. It may sound weird, but the setting can have its own personality, and that personality will come through; it can be pleasant most of the time, but there are times when it will be a challenge. The same applies to vehicles and weapons. And I'm not talking intelligent swords or vehicles that operate themselves. Consider Bonaparte from Tank Dominion or Mr. T's van; when those vehicles were in trouble, their drivers were in a state of distress, just as if a son or daughter were in the hospital. When they perform beyond expectations, their drivers are ecstatic. They also encourage them, love them, and basically treat them as their kids. THAT makes them characters, and just as important to the script as the characters. Consider the care some characters give their weapons; those weapons are characters as well. When you say to yourself, "Man! I liked how Excalibur cut through that guy!", you are no longer treating a sharp, pointy as a mere object, but as one of the cast.

In short, not all characters are not necessarily entities that interact with other characters. Keep that in mind when you are

listing the characters and equipment; there will be some overlap so be prepared for it.

Problem Characters and How To Deal With Them

There are some basic problems when people build characters. They either give the characters too many advantages or disadvantages or forget to flesh them out. There are also characters that are forgotten or otherwise abused by writers. As such they need a little love; here are some ideas for making them better characters.

Mary Sue/Gary Stu's: Some characters have too much power on one hand and enough psychological issues to pay off a therapist's student loans on the other. Girls' comics are filled with these characters, because not only is empowerment considered a great thing (thus the sheer number of abilities), but so is sensitivity and admitting your problems (thus the sheer number of personality problems). Another way to look at it is that they are given so much, and so must have a number of things to make up for it. There was a reason that I suggested no more than four good things and no more than two bad things; it's a simple way to balance out your characters. You should always strive for balanced characters, and should avoid characters that have too much going for them in either side of the balance sheet. They are just too hard to write and rarely become fan favorites.

Caricatures: At the other end of the spectrum are the shallow characters, those that are more caricatures than characters. The problem is that these characters aren't intended to be serious characters, and so the writer doesn't treat them seriously. It needs to be remembered that all characters need to taken seriously, no matter how silly they are; in fact, the silliest characters come off as even sillier if they are played straight. Thus, you need to make

sure that all of your characters are fully developed, and that characters that are caricatures show themselves to be fully developed in order to take your running gag go to the next level.

Disrespected Characters: Some people just shouldn't write certain types of characters. This is usually most obvious when it comes to military or religious types, or even authority figures in general, but it can apply to any type of character. The obvious example here is the character who is treated as a caricature; the FBI agent that is far too official, harasses the main character while spouting arcane laws or interpreting laws in order to nail the main characters, and is basically not someone who you want to invite to Christmas dinner. More than any other character, this kind has the highest possibility of taking your readers out of the book, and possibly ruining any scene that he is in. The only real advice I can give you here is that you need to be aware of those types of characters that you don't have any respect for, and try to avoid writing those kind of characters. If you do need to write those characters, then you need to make an effort to treat the character respectfully.

Mandatory Characters: Every genre seems to have those characters that are mandatory, and that everyone seems to make sure that they are in stories of that genres, such as the barbarian in fantasy stories or the cool alien in science fiction. Jut remember that there are reasons that they are "mandatory" characters and take advantage of them. The obvious solution is to don't worry about omitting the character type, and be happy about it. However, if you're using the character as part of a running gag, then see the notes regarding caricatures above.

Love Interests, Sidekicks, and Villains: Always make sure that these characters are well-developed. One of the problems is that these characters are part of the story, but combine elements of

various character types as mentioned above: Sidekicks may be treated as puppies, love interests may simply be elevated trollops, and villains limited to the Snidely Whiplash version. Respect these characters, as they are the most important ones to your story, and the ones that pop up the most. Used correctly they can add a lot to your world, but if you abuse them then they will drag your story down with them.

Remember this advice, and your characters will love you for it and you will have some great stories.

Being Diverse Just For The Sake of Being Diverse

Consider the Planeteers for a moment. It's a multi-racial group of kids serving the greater good; each has a power ring giving them control over an elemental force that when combined creates a guardian of the planet. There were three boys, two girls, with an Asian, a native South American, a black African, and two Caucasians; a more heterogeneous group you are unlikely to find. However, they do raise an interesting question: Is there a reason to include every gender and race in your story just for the sake of inclusiveness?

The problem is that too many people worry about political correctness. There is a fear among far too many writers that by excluding a particular group the writer seems to be racist, sexist, homophobic, whatever. The obvious reaction to this is to create a character that has the appropriate qualities and is likely to relieve the fear of being exclusive. The problem, however, is that having a character just for the sake of providing a character with the given qualities is likely to ensure that you will not really care for the character and it's likely to show in your writing.

18 Jochim-Character Building

This means that you have a character that is there for no real purpose beyond making someone else happy, and that is something you should never has as a writer. Every character should fulfill a purpose in the story, be it to drive the story, to serve a symbolic purpose, or even as the expository focus. A character that is there just for color may as well be little more than the background, and eventually you will be treating that character precisely as that. Worse, he will drag the story downand the fans will notice. Worse, those that were drawn to the comic because of that character will get tired of the comic, and will soon start spreading a negative word about the comic, nailing you for precisely the reason that they should.

Now, if you use the character so that the character serves a purpose, go for it. Do not feel as if you need to use the character a particular way, such as having the black person inject some level of urban cred into the comic. Kwame, the black kid of the Planeteers, was pretty much a waste because he served no real purpose in the group; it's almost as if they tried him in every position and it just didn't fit. Compare to Wheeler being the leader of the group, Linka being the voice of reason, Gi was the brains, and Ma-Ti was the passionate one. Kwame tried to be the leader but he was virtually ignored in that role and Wheeler ended up taking over the role. As such he came off as a token character in a multi-cultural group; he should have focused more on being the equipment guy as that niche needed filling.

The bottom line is that only include a character is you have an internal reason to have that character around; otherwise cut the waste off before it becomes waste. At the same time, if you do include a character for the purposes of multi-cultural consideration, do not feel obligated to use that character in a stereotypical fashion; feel free to have a black character who is a doctor rather than an ex-street thug. They are your characters; feel free to have some fun with them and use them as they best

serve the story, not some idiotic sense of racial guilt that almost always ends up messing things up. Your characters should be guilt free for maximum effect, not minimized to serve some stupid token use.

Using Something From Mythology
We have all wanted to take a creature from mythology and warp it to our own needs. There have been good ideas and bad born from this, and so I suppose I should mention some of the considerations of making this work.

The first is finding the creature. You need something that fits your comic, and adds to it. You need to find something that requires little adaptation but will still work as a character; the ideal is to find something that is at least humanoid or has a humanoid form often enough to work with the other characters.The usual temptation is find something really unique and go from there, but that usually doesn't work as well as you would think as you either have to tame it to the point that it doesn't resemble the origin creature or it has some sort of problem that makes it difficult to adapt.

On the other hand, using a variant of an established creature will also usually fail if you try to make it too unique; you want to cash in it on its "brand", but want something unique. Just remember to keep enough of the base creature to give readers something familiar and you should do fine; you do not want to mutate too much or it's a new creature. The worst example here is the Twilight vampire: The shiny vampires make sense in that world but there are too many differences between expectation and example for it to really work.

You then want to research the creature. You want as much information as possible on it, both to make sure that pre-existing fans of the creature will not be too mad at you and for the sake of

the illustrator. You want something that the illustrator can sink his teeth into while at the same time making sure that you are doing right by the creature. Although I can understand that iconoclasts would prefer to just wing it, you'll find that nine times out of ten your research will give you some additional inspiration, usually some minor bit of trivia that is incredibly interesting, making it easier to get your mind around the creature, and making it really come to life. You also need to avoid the "the myths were wrong" concept; the idea is to at least resemble the expected creature, or you may as well as start fresh.

You also need to get the iconography of the creature right. Mythological creatures fit a niche and by staying in their niche they can add a lot to your story. This applies from something as simple as werewolves and people's fear of change and predatory animals to school ghosts and kids' fears of the unknown. Obviously they can come out of that niche once in a while, but using a monster in a non-traditional way needs to create confusion, and should be avoided if it is just for the sake of being cutesy. If you need to, do not be afraid to come up with something new just to feel a niche in your story if the creature you are adapting looks like a bad fit.

Lastly, just have fun with the critter. If it isn't something you can have fun with, then either create something new or go with something else. If you are having problems breathing life into something, then the problem is either that it doesn't fit with your plans, or it just isn't something you like. Keep in mind that it does not need to have a unique personality; sometimes a monster just doing what it does is more than enough. Sometimes you do not need a new character so much as you need a plot device, and that works as well. Make sure your monster fits the comic, and you should do fine. Don't just pull a creature from the encyclopedia, but breathe life into it and give it its own fire if you want it to work.

A Quick Checklist of Do's and Don't's

Do's:

1) Have a good reason for any exception. I'm placing this hear as a first rule because each and every suggestion has this as an exception: You can do anything you want as long as you have a good reason for it. Just make sure that the reason is better than "I can do it!"; have an actual reason for the exception based on the needs of the story, not just because you want it that way.

2) Diversity is key. I don't mean this in a strictly racial sense; you need a variety of powers and weaknesses. Each character needs to have their niche and speciality; a character that can be outdone by another character in every way possible is going to be useless. By the same token, a common weakness is going to take your entire team out of action, and that's annoying to readers (not only is it basic manipulation, but it's going to ask the question of why aren't they taken out more often). Also, the more people you have the more likely some character will strike a chord with readers.

4) Avoid cliches, but don't run from them. This is the hardest thing to deal with; you're going to want to create something that's unique, but you can't avoid the basic cliches because they work . From a practical perspective, this means not having to re-invent the wheel every time you sit down to write; that makes things a lot easier, especially when you are trying to write in a familiar genre. Also, keep in mind that some readers are looking for familiarity over new territory; by using the genre's cliches you can give them something familiar even as you're trying to do something new. So use cliches, but don't use them too much.

5) Have fun! I can't stress this enough. Too many writers forget this, and so get burned out quickly. If you aren't enjoying it, then

no one else is either. At the same time, don't do something you don't want to do simply to make your comic something more popular or profitable; ironically, that almost never works as well as something you love, especially if that love comes out in the writing. Follow your heart, and hope others will follow.

6) Always have someone with glasses. A personal preference, but I find that groups that have at least on character with glasses and/or goggles is much more interesting than one without that accessory. But that's just me...

Don'ts:

1) Say that there is something you won't do. This limits your characters and your plot, usually artificially, and that's not a good thing. A lot of fantasy stories don't have elves; by advertising that, they may be favorites of elf-haters, but they usually replace elves with something similar or that takes their niche. Obvious stupid question: Did they actually eliminate elves? In the super-hero genre, you find comics that don't have costumes, secret identities, or world-shaking abilities; what fun is that? It also prevents you from have to be an apologist later on if you decide to introduce the banned subject. Don't do it in the beginning, and you won't have to backpedal later on.

2) Think that you require a pantheon. It may help to build your universe, but it's not necessary. You can have a character that is the only super-powered being, or at least the most advanced or experienced. Just don't get roped into thinking that you need a team when you want to write a book about a character that works alone; sometimes the book with a solo hero can be much more effective than a book with a forced group.

3) All characters need powers. Consider Iron Man; he has no powers, and yet is able to keep up with the other Avengers. Batman? He's won almost every fight against Supes. Don't feel that you need to have every character having powers in order to have a great comic. In fact someone without powers can be exactly what the book needs, especially when the characters are pretty powerful, as it gives a better sense of just how powerful the others are. That, and they can be all sorts of fun compared to the others.

4) Avoid common origins. Although it irritates a lot of people, having a common origin liberates you in a lot of ways. You don't need to keep everyone's origin straight, you don't need to allow for different mechanisms, and you can leap straight into the story. And it gives you an excuse to have everyone join up and fight someone if the secret is to be revealed or if that common origin is threatened. This isn't to say that you need a common origin, just that you shouldn't avoid one because you were told that it sucks.

5) Obey the rules. It's your story! Not anyone else's; they aren't responsible for writing or illustrating it, and they don't know where you're going with it (if they do, there's problems!). Just remember that if you're going to break or bend them, understand why the rules exist in the first place.

In short, it's your story. Figure out what works for your story and use it. It's up to you to decide how you want to use the cliches and advice everyone gives you so just do what works for you. It is up to you to heed it or ignore it; just have fun with it!

Top Ten Cliches to Avoid

Some cliches need to be stopped. To help you avoid cliches, here are the Top Ten Worst Offenders:

10) Vampires. They're dark, angsty and supernatural. Perfect for artists that are trying to explore their dark sides.

Unfortunately, few think vampires all the way through. They look at the angst factor, mostly the night-only existence and the parasitism, and possibly the romantic side, but not the advantages of being a vampire. Once you get past the need for blood and darkness, you don't have to pay taxes, the money you were paying for most bills and food becomes disposable, and you can concentrate on what makes you happy. Okay, so you can't have kids either, but that's sorta plus/minus.

Also, not all vampires are going to be interested in politics. Too many stories have vampires involved in high-school level politics, and the reality is that most immortals hate high school. With all of that time on their hands, they are more likely to take up a hobby and fully explore it; this means that the majority of vampires are going to disappear into the shadows. Given the likelihood of vampire killers it's even likely that more than a few will make it their mission to oppose them, taking even more out of the politics. And don't forget that a lot of these entities are interested in dealing with people just to feed, and in a modern world they don't need to.

On the flip side, there are those that try to find psuedo-scientific reasons for vampirism. Obligatory: Huh? They haven't thought one major thing through: Vampires only work when they are mysterious, and they end up not working as well when their secrets are grounded in reality. Not saying you can't do it; just be aware that it's not necessary to enjoy the concept, and it usually actually kills them. If you are going to use vampires, don't get

drowned in the angst, and consider that they would revel in their advantages (such as their heightened senses, the ability to pursue things for a longer period of time, and immunity to a wide variety of things). If you are just interested in portraying them as angsty entities more interested in politics than anything else, it may be time to try something else.

9) Collector Comics: The basic idea is that a hero (or group of kids) are looking for a group of objects or animals in order to solve his (their) quest. Although great in that success is measurable, and tension is guaranteed to mount with each piece collected, it starts getting monotonous as battles start to mount, especially if every fight is the standard "old trick gets negated, hero almost loses, finds a new trick, wins" formula. This is great if there are just a few pieces (Dr. Who's Key of Time only had seven pieces). But there's a reason it works great in games, and not so great in comics: There's almost no way to avoid it from becoming monotonous at some level. After all, each quest needs to be unique or else it gets annoying, and the irony is that the majority of quests have been done by someone else.

This is a favorite of new writers because it has measurable goals. However, there is the problem of what to do when all of the pieces have been collected, and you need to make sure that not all of the stories revolve around finding pieces. While this can be great for an all-ages book, the problem is that the characters have to have some serious reasons for what they are doing beyond just collecting; discover those reasons and this can actually be a pretty strong concept.

8) Magical Girls: I'm not trying to be anti-feminist, but heroic girls set the feminist movement back by ten years each time they show up. ("Super-Sailor Charon, let's defeat Masculinor and then go to the mall! Magnifence Cherry Beam of Cheeriness!").

26 Jochim-Character Building

Yuck. While I'm for female empowerment, there has to be more to your comic than fighting against easily defeatable bad guys or your comic is just seen as so much filler.

The easy solution is make sure that none of the girl's involved are Mary Sues (almost-perfect with special abilities, flaws that are more dramatically appropriate than real, and worry about their perfection). If you do have them, kill some of their specialness, and give them normal issues, not hyped-up petty ones (such as she needs to defeat the bad guy quickly in order to make a date or because he messed her hair-do). You have to get good at balancing real-world issues with their fantasy ones, and the two do not need to always coincide. Real-world women need to balance job and life, and this is a great time to make a statement on that; just change it to school, life, and fighting monsters and you have it.

Also, make the guys real. I like WITCH because the recurring males are realistic guys, not merely foils for the girls. Even without powers, Caleb (the rebel leader), Blunk (the "pet"), Matt (Will's love), Martin (their fan), and Uriah (Caleb's friend) are just as vital to the fight as the girls, albeit in far different capacities. I could have an episode with just those characters, and it would be interesting. Contrast that with the guys in the Winx Club, who are not only easily replaceable but don't really contribute to the fight. Keep in mind that the guys should be able to hold their own and you should do okay.

Last, don't try to be feminist. It invariably works against the story because it always feels forced, and once you start forcing characters to do things you start it on a downhill slope. Just let them evolve as characters and they'll make all of the points you want to on their own.

7) Game Comics: This is not to say that there aren't great game comics. Penny Arcade and Goblins are great examples. However, because gamers tend to be computer literate, and some are decent artists, they try too hard to relate what happens in games to others, and it just doesn't always work. The problem with game comics is that they need to work as comics without the game; too many of them rely on the game for the humor and that doesn't always work. Penny Arcade works because the lives of the characters are more important than the games they make fun of, while Goblins works because it focuses on the lives and desires of the goblins. That one is a great satire of the gaming industry and the other looks at what happens if the monsters thought like characters would not work without that.

If you are serious about making a comic based on a game, do up a script, and then show it to someone who is not in your immediate circle. If they think that's entertaining, go for it. Otherwise, just put it down and either try something else, or just do it for yourself and your immediate circle of friends.

6) Conspiracy Theories: Every action has a reason for happening, right? And, as we're interested in looking for reasons behind why things happen, we're liable to assume that if we can't see the reason, then someone made the decision. Most people realize that some decisions are by nature arbitrary; a decision needed to be made, but several options were acceptable, so one was chosen. Others, however, believe that there is no such thing as an arbitrary decision, and that every decision is made for a reason. The next leap of logic is that the reasoning behind the decisions is part of some struggle, and that there is some sort of war going on, making every decision important. Thus are conspiracy theories born.

28 Jochim-Character Building

A lot of writers like them, as they feel powerless in their own life, and seek to demonstrate this by showing how powerless the average man in a world where all his decisions have already been made. They then make the hero someone who rebels against the conspiracy, proving that there is free will in the universe. The issue here is that it removes free will from the situation. After all, the easiest way to deflate tension is to make it obvious that any decision that's going to be made has already been made. Think about this for a moment: You have two organizations that have been going against each other for milennia, and they can predict the other's moves.

So, if I belonged to one of the big organizations and I knew someone would be making a choice, and I knew how the other organization was going to react, then why not give him some sort of information that affects his decisions, and towards my preferred result? This removes any actual choice, and gains me an ally against the enemy organization because he feels so good that I allowed him a choice, even if he thinks that he's acting against mine as well.

In short, you can never really tell when the characters are making decisions and when they are being manipulated. While this can work it can get a little depressing after a bit. Just pointing out that when you start down the path of conspiracies, you remove a lot of dramatic tension from your comic, which relies on dramatic tension.

5) Team Comics: Teams can be good and bad. The good is that you can split up tasks, have a range of personalities, have intra-team conflict, and have an easy excuse for some exposition. These are all great things. Splitting up tasks allows characters to define who they by what they do. A range of personalities allows people to pick someone they like to root for. Conflict is always good,

and if you make it natural (such as five people living together in cramped quarters) rather than forced so much the better. And it's only natural that you need to explain things to someone in the group that wan't there or isn't following along.

However, too many writers (beginning and advanced) learned too much from the *sentai* (think: Power Rangers) school of teams. This means that the team has the following types:

Leader: This is the guy in charge. He's only wrong when it's dramatically right, he can do whatever he wants and no one cares; he is the hero, after all. The older brother of the group and the guy who the Lone Wolf usually rebels against. If there is a long-term romantic relationship, he's usually involved somehow.

Lone Wolf: The rebel. The guy who everyone likes because he's straightforward and does what he wants, something that they can't do. He's the perverted older cousin who's probably into whips and chains. Whatever the leader aquires, he wants. Usually.

The Geek: He knows everything except how to deal with social situations. Usually the least liked character because, well, no one likes the group brain. He's the most dependable of the group (except when it comes to shooting the 300'-tall monster directly in front of him). He's the little brother of the group who is sex-obsessed and the group mascot. If the group has a fanboy, The Geek is usually it.

The Brick: He can lift pretty much anything, punch through pretty much anything, and take pretty much anything. Usually the group mechanic. He's sorta the fun friend of the family; the guy who kicks your butt at Mortal Caliber VII, makes you cringe through his puns, and is the guy you go to for advice, or tickets you can't get yourself.

The Girl: She points out the obvious, is the love interest of The Leader, temporary goal for romance of The Lone Wolf, defender

of The Geek, and grudging friends with The Brick. If it's a unisex team, change "love interest" to "best friend" and "for romance" to "for assassination." She is yin to the team yang, and is usually the most effeminate. Aggressively effeminate. Usually the best shot in the team. And the richest, especially when there is no monetary system in the universe.

Now, it may look good, but EVERYONE uses the blueprint without thinking about making changes. When they do, it's the leader that gets in the shorts. If they take characters away, The Brick goes first followed by The Geek. And if they need a non-binary character they just change the gender of The Girl or The Brick. It's a working cliché because it's an effective starting point, but be aware of it anyway, and try to change it up somehow.

4) Elemental Powers: This is starting to get ridiculous. Change that: It is ridiculous. The default is the clssical Greek elements Fire, Earth, Water, Air, but any theme can work. Each character has abilities that stem from their respective element, and personality traits that stem from their element. Although these are visually interesting, they are sorely lacking for imagination. Just be aware of the problem, and plan accordingly.

[Just out of curiosity: Why is it that the oriental elements are wood, metal, fire, water, and earth, but you only see the Greek elements of water, fire, earth and air? And why rarely (if ever) those from the periodic table? Even manga writers default to the classical Greek elements....]

Angsty Hero: O Woe is I! I accidentally killed my best friend, my lover commited suicide because I was a day late coming home, and my dog has worms. Oh, and my house is trying to kill me. Today on Oprah: Angsty heroes and the fangirls that love

them. Note: These people would not survive Dr. Phil.

Look: I understand the attraction: Girls like guys that need them, and this guy needs something alright. I know that the angsty hero is an old literary tradition (yet another thing we can blame on Ancient Sumeria: Gilgamesh, anyone?). And I know his existence validates that of the artistically dark. But...give the guy a good day once in a while! Gilgamesh let his hair down! Elric did smile every so often. King Richard cracked wise. Even Macbeth had fun!

But this hero has nothing good happen to him without cost. If he a million bucks, he gets sued and ends up owing money. His new car is possessed, your choice if it's demonically or actually taken.

At some point just let the guy have some fun and loosen up; it's going to make for a boring comic if all we see is someone keep getting dumped on by life. We some reason to keep checking in and if it's just to see more bad news we probably won't be checking in much longer.

2) Avatar/Sprite Comics and Doujinshi: For the three individuals who don't know what any of those are:

Sprite Comics: Take a video game, take the characters and use them in your own comic.

Avatar Comics: Take avatars from Gaia Online and use them in sprite comics.

Doujinshi: There are many translations, but the one in use here is fan comics using the characters that the fan likes. Included here because, well, if sprite and avatar comics are examples of someone being a lazy illustrator, doujinshi are examples of lazy

writing.

I'm sort of in a weird spot on this one. On one hand, I appreciate not having the ability to draw/write and having a cool script that you need to see done. But...this isn't the way to do it. Besides the obvious legal issues, there's just a lack of imagination here. I mean, you're taking someone else's characters, throwing them into situations that their creators never intended, and then claiming that you're creating something original. Worse, I see it justified because it's a great way to get started!

While I can understand how some people get started this way, it is just a start. It's just training wheels; at some point you need to advance beyond someone else's works and start on your own. To be a good writer you need to be able to stand on your own two feet. You can't rely on the crutch of using someone else's creations as the base of your own. It's fine to be inspired; it's lazy to copy. Find the difference, and you begin to walk.

[I'm including this under cliches because cliches are just lazy creating. It just fit...]

1) One-Dimensional Institutional Figures: Okay, this is my least favorite cliche of all time. I appreciate that a lot of artists don't like religious figures; there are a lot of reasons to dislike people that put a lot of limitations on what you do. And I understand why military types aren't exactly popular. All authority make for great targets, and the bigger jerks that they are the better the targets.

However, that shouldn't be an excuse to make them one-dimensional. When you make any excuse to have one-

dimensional characters in your strip, you're wasting my time. All of your characters should be well-rounded, even the jerks, or your comic will suffer. You can't just offer caricatures of real people because you have to know how your characters work in order to get the biggest bang out of your characters; your need to be able to get behind your characters, even the ones that you hate. Especially the ones that you hate.

At some level you need to realize that any group has those members that aren't exactly shining examples of their organization; the more in the public eye the group is, the more likely you're going to see the dregs of that group. The problem is that everyone group is full of heroes and villains; it's just harder to ignore the ones you hate when they aren't kept hidden. That's something you need to remember: Even in the most villainous organization there are heroes and even in the most heroic group there are villains. You need to figure out who those people are and figure out how to bring them out more.

Always remember that characters need to serve the plot. Sure, they're important, but a character that doesn't serve the plot destroys the story.

HEROES AND VILLAINS

I am not going to go into a lot of depth when it comes to dealing with heroes and villains. There's been a lot of work in the field, and there's not a lot I can add. If you haven't Joseph Campbell's Hero of a Thousand Faces then you should, but that is just the beginning. Here are a few additional thoiughts on heroes and villains; enjoy!

Avoiding Mary Sues

One of the biggest problems beginning writers have is the Mary Sue. The problem is to create a balanced character that the reader can identify with, while at the same time creating a character that is powerful enough to take on just about any challenge that you can throw at them. It's a lot easier than you would think, but you need to make a lot of decisions. Oh, and just for the sake of not being sexist: The male version is called a "Gary Stu", but this article should take care of both problems.

The character needs to have a limited skill set. A Mary Sue has a ridiculously huge skillset; this allows her to deal with almost any problem, and remove the challenge from any encounter. Although there are some characters where it works well, that's because they are also dealing with equal adversaries where that huge skillset works. Normally, however, having a huge skillset is a bad thing and removes the challenge. You need to limit the skillset to a double handful of skills, with a further limit that if the

character is highly skilled, skills should be eliminated from the pool. In other words, if the character is the best shot in the world, the character should only have a few skills. This can represent focused and/or limited training, but the limited skillset gives you more options.

The same especially applies to power level. The character can be really powerful, but only under certain situations. And those situations need to be rare situations; the more powerful the character the less often that the situation should come up. Do not power game this; "only during a syzygy of six planets" should not come up every other day. If the character can depend on the power enough that it is a practically standard issue, then you have not limited the power enough. If everyone is powerful, then you can take off the limits, but keep in mind that you want all of your characters to be on the same level, roughly, as one character with overwhelming power just won't be as much fun as you think.

Popularity is another issue. Keep in mind that the if the character is an outcast, that character should not also be the most popular person; the two sort of cancel each other. Also keep in mind that popularity takes some effort to maintain; you cannot be friends with everyone without owing everyone favors and that you need to play politics in order to remain popular. In other words, if the character is a rebel and avoids politics, the character should not be popular, regardless of how important she is. On the other hand, if the character is popular then the character is going to be spending a lot of time dealing with others. Just a consideration…

Last is that the character needs to be reasonable stable emotionally. A character that bounces from one emotional state is going to drive readers crazy, and drive them away. This is not to say that the character is only allowed one emotional state, but that the emotion has to apply to the situation. Even Batman has a range of emotions, and that he is capable of expressing joy, hate, and anger, usually applicable to the situation. He does not, however, bounce from wall to wall when he is happy, and even when he is angry he maintains just enough control to make the situation fun to watch in a "will he, won't he, he just might, he'd never" way. Just maintain some stability, and you should be okay.

So…Limit the skills to a particular skillset. Limit displays of overwhelming power. Debate popularity. Generally keep emotions in check. Do that, and you should have limited problems with Mary Sues. I hope…

Could Your Character Survive The Bar?

Any time I create a character, I ask myself one simple question: Could I see that character at a bar? It doesn't need to be an Irish pub, even though it helps; the basic question is if the person (note: "person", not "character") is capable of holding a conversation. Even the most obsessed psychotics are capable of holding a conversation; even an autistic can communicate their desires, albeit in limited fashion. In essence, is their something in the character that makes that character a person, with desires and wishes, balanced against their flaws and handicaps?

The problem with alien psychologies is that the writers too often ignore that even an alien psychology has to deal with the same basic motivations of any human: They need to survive, breed, and eat, however that is defined for the alien. It's easy to forget that, but even an insect has a motivation, even if it is just finding the

next meal and surviving. Most of the alien psychologies aren't that alien when you analyze them from the stance of what their motivation is. There is no real alien psychology, at least, not in the since that it has no similarities to a human one.

The problem is that when people think "alien psychologies" they are thinking that an alien needs to have its own motivations that make no sense to other sentients. The reality is that even regular humans have motivations that are alien to other humans; consider an altruist from the perspective of someone who sees selfishness in everyone, for example, or someone who tries to live their lives morally in the eyes of a dedicated sinner. Consider how many writers treat immortals as entities that never graduated high school; how many vampires are more interested in what amounts to high school politics and are worried more about social ramifications than pursuing their own interests?

That's something you need to consider when you write. You need to ask yourself just how alien people are and decide if you are interested in trying to make those alien psychologies work or exploring how delusionary they really are. When it comes down to it the only true aliens are those we choose not to try and comprehend; all personalities are ultimately decipherable and there are no real aliens. You just need to figure out how they work in terms of your story and what they can bring your story. You'll find that people have more in common than you would think at first.

It basically comes down to that I bet you could at least debate Nietzsche with Darth Vader, and it would be interesting. A good writer will create the full personality of his characters; try to hold a basic conversation with one, and if you can, then the character is solid. That's sort of the genesis of the bar test; any two characters should be able to have a conversation in a bar or else

one or both of those characters may need some work when it comes to being fleshed out. This applies especially when it comes to heroes and villains as they are usually the ones that are the most apparent in their motivations; if they can't discuss what is important to them then they have some serious issues you need to work on. So have your characters meet in a bar, at least in your head, and let them talk; it's the only real way to see who works and who needs work.

How A Villain Should Work

The basic truth to any hero is that he's only as good as his villain. And as such, the villain bears some serious consideration. There are basically three kinds of villains: Arch-rivals, Failed love interests, and Elementals. Arch-rivals are those who naturally oppose the hero, either because of a mutual antipathy or antithetical philosophies. Failed love interests can cover a lot of ground. Elementals represent some sort belief or ideal in the purest form.

Arch-rivals are the meat of the relationship. The hero needs someone who is capable of testing him, and is going to make the challenge seem interesting. Sometimes the rivalry goes way back such as how Dr. Doom has been challenging Reed all the way back to their college days. Other times, it goes to when they first clashed; Lex Luthor wants to slam Superman because Superman sent him to jail when they first met. And then there are those that simply represent different perspectives; Venom is the evil version of Spider-man.

However, the basics of the arch-rival will always be the same: The villain needs to challenge the hero, and has a reason for the grudge. The challenge is the fun part, and it doesn't mean that the villain has to have the same powerset as the hero, or even the same origin; Lex Luthor has done rather well, and he usually

doesn't even have a powersuit. Luthor challenges Superman by threatening his ethics; Luthor is a womanizing, plotting, unrepentant bastard, and proud of it; he has fun doing what he does, and he's pretty good at it. But...he represents a threat that the Blue Boy Scout can't handle easily; he can't physically attack Lex, and Lex is a far more complex problem because he is part of the power structure of Metropolis. Lex has always been a fun villain; he's evil, he knows it, and he's always steps ahead of Superman.

And the grudge is just as important. No matter how multi-dimensional your villain is, if he doesn't have a grudge against your hero, then the villain just doesn't work. When you think grudge, screw the logical side of your brain; apply the angry side of your personality. And I'm not talking merely being anti-authority; I'm talking the villain has been arrested or humiliated by the hero, or thinks that he has been. Dr. Doom has gotten a lot of mileage out of Reed embarrassing him back in college, when Reed tried to point out his math error; he's seen every defeat since then as further humiliation. Venom has been a rival of Spider-man since Spider-man rejected the symbiote.

And, even though I'm using a super-villains, this doesn't apply solely to them. It can apply to high school (the Supreme Jock and Ultimate Popular Girl are the obvious cliches), the office (the backstabbing secretary and the sadistic boss), or even two sports rivals. There is almost no limit to where you can find the arch-rival!

The Failed Love Interest can be downright fun. Besides revealing part of the hero's psyche (what kind of woman the hero likes can reveal a lot), it creates an interesting character that can sometimes annoy, sometimes support the hero. The FLI can be anything, from a stalker, a radical (getting into trouble by

proving how good he is, for example), ethical rival (loves the hero, loves stealing more), or even obligation (needs to marry the hero in order to fulfill some personal quest). Anything that applies to the normal love interest applies to the failed one; after all, the FLI could have been the love interest except for some "tragic"mishap. Except, of course, that the FLI is just a bit twisted; she may be out to kill the hero, humiliate him, or even just be doing what she is doing in order to get the hero's attention. And, even more evil, she may team-up with the hero in order to save him; nothing ends a romance like the death of the romanced.

A special note on this one: One of two situations can really mess up the situation. The first is that the hero could represent the one way in which the villain is a potentially good person. This is great for tragic storylines, or when you just want to make the villain a bit sympathetic. It can even be used if you eventually wish to redeem the villain, and this is usually the first sign of that. The other is much nastier. In essence, it's a version of the Arch-Rival, but nastier; the FLI is trying to prove herself, and the easiest way to do is to be the center of his universe, which is naturally enough his arch-rival. Or, the "failed" part could be humiliating to the villain, and forms the basis of her grudge. This can get really weird...

The Elemental is something that is intrinsic to super-hero and fantasy comics. It requires a focus of mind that just doesn't work in other genres. I'm not referring to characters made of some elemental force; I'm referring to characters that represent some aspect of the universe. Consider The Joker for a second: He represents the evil, insane, twisted part of the human psyche. He and Batman clash more because they represent opposing forces (Sanity versus Insanity) more than any mere rivalry. By representing some aspect of the Dark Side of the Universe, the Elemental allows you to play with the fundamental forces that

make up your universe, and show that it can fight back on its own terms.

Sort of makes The Joker scarier, doesn't it?

By using these three kinds of villains, you do something weird: You give the hero something to do. You give him a chance to show why he's a hero, why he fights, and what he's willing to do to win. If you look at the support staff as providing the reason for why the hero does all of that, then the villain is ironically the best support a hero could ever have. Keep that in mind, and you will do really well!

Why Your Heroes and Villains Need Organizations

Keeping it real isn't just about adding real relationships; it's understanding how those relationships work. There's a reason anti-heroes are popular; they don't have any real relationships to slow things down and so they are easier to write about. However, by throwing some real relationships at a character, you add not only depth but can create hooks for when you are running out of steam later on. That is, while being part of something may slow the writing down a little, an organization can actually help a writer keep things going.

Consider James Bond. Not only does he gain his very license to kill from MI6, but the organization itself keeps things going. He not only gets some real cool toys, an expense account, and easy transport to any location in the world, he also has set goals to accomplish; all of that eliminates minor things you do not need to worry about later on. You can create foreshadowing with the items (exactly how does a watch that creates an EMP going to be useful in the field?). That expense account can be good thing

when he needs a boost or specific funding, but it can be taken away as the situation warrants, either by the organization, by theft (especially if it's represented by credit cards), or by situation (he's far away from civilization). The transportation puts him wherever he needs to be.

Best yet, though, are those goals. They provide the initial hook, the push that gets things going. Bond gets an initial list of things to do, and reason that the bad guy needs to be defeated. The important thing to keep in mind is that these goals are not ironclad; if the mission goes bust obviously those goals will change, or at least be modified a bit. But, they provide an original reason to get Bond into the field, and that's good enough.

And don't think that the organization is nothing but help. After all, Bond needs to follow certain regulations before he can kill someone, and there are certain protocols that need to be followed for him to do his job effectively. He also has to worry about jurisdiction (there are certain areas where he can't go and he can't kill people for everyday crimes). He's even been hindered or helped depending on MI6's reputation (and not only the bad guys have disliked MI6). And that's ignoring the various office politics and interdepartmental conflicts that have popped up from time to time, or when he's seriously screwed up and so MI6 has restricted what he can do, has forced him to do menial tasks, or assigns him to duties a rookie can do.

And this applies even to gangs. The equipment, amount of money, and transportation available may change, but there may be other perks available (reinforcements, living arrangements, even internet access). An organization can be a source of strength as well as (and this is important!) conflict.

And even gods aren't immune to this. Consider Thor; his friends (the elves and gods) and enemies (giants and evil gods) are defined by the group he belongs to, as are his duties (defend the gods and humanity). He gets access to some pretty weird stuff (a cart pulled by goats, a really special hammer), transportation (a rainbow bridge to anywhere), and some pretty interesting resources (an entire army of dead warriors) if he needs it. Not to mention sibling rivalries that are even weirder (his brother Loki can be good or evil, depending on the writer, and either way he gets Thor into trouble).

Of course, anything that's good for your heroes works for your villains. Can you seriously imagine a decent villain without mooks to send up against the heroes, a day-to-day group to make sure that his plots keep advancing, and the logistics to make all of this happen? It gets even better when the villain has a business to provide him money and fame or a government group to give him discretionary powers. A bad guy with a credit card is bad enough, but give him a group of loyal minions and he gets all sorts of scary; even a hacker with a group of friends is far scarier than a mere troll with an attitude.

The bottom line is that everybody belongs to an organization. And, for better or worse, there strengths and weaknesses belonging to one. As a writer, you need to learn how to mine those in order to maximize the conflict in your stories and to have a lot of fun with the characters.

EVERYONE ELSE

One of the problems with most comics is that they focus in on the heroes and villains but few of the other characters. It's sort of like concentrating on the meat of the sandwich without worrying about the rest of the sandwich; if you forget about the bread, condiments, and other fixings you just don't have a great sandwich. This is why you need to worry about more than the hero and villain; you need to worry about everyone in a comic in order to make the comic an incredible success. Well, here's where we look at the other parts of the sandwich in order to create a much more filling meal.

Why You Need Extras

Any movie production has extras. The same should apply to comics as well. Wait....It does!

Extras have a very basic use in comics: They not only act as window dressing, but they fill things out. Extras are those characters that do nothing, yet are all around. Those characters in the background haggling or just walking around? Those are extras. The guys ordering beer that we'll never see again? Extras. The geeks being slapped in the foreground that we have no reason to care for? Extras!

Extras are characters that can be used for humorous purposes, or to establish that world is populated by more than the main characters. If you want to slip a joke in, or a subtle bit of

exposition, your extras come in really handy. They can also be useful to establish that your world is busy as the real world is, or to show how extravagant a party is. Admittedly, they aren't a writer's issue, but the writer should bring them up to artist.

Also, bear in mind that there several advanced types of extras. The first type is the "mook". You know those characters that all the heroes wade through on the way to the main action? Those are mooks. Mooks are the ultimate window dressing for the bad guys; they do all of the common tasks that the main bad guys have neither the time nor inclination to do, such as balancing checkbooks or kidnapping sidekicks. The palace guards, or any other character that is just window dressing and usually appear en masse are also mooks.

There's also insignificant characters, which are just modified extras. They may have a use, but they are usually just background characters. "Nurse Joy" from the Pokemon series, for example: She may be a running joke (every town has one!), but she has no real effect on the plot, and her capabilities (outside of medical and causing Brock's heart to race) are not well-developed. As such, she's basically still just an extra. The local barkeep is another example, as his staff. They may give the tavern a certain stability, but they are only useful as far as the tavern is concerned; they are useless (plot-wise) outside of it.

Oh, and let's not forget "fonts" (short for "font of information"). These are characters, like snitches, sages, and the occasional barkeep, whose sole reason for being is to dole out information and get quests started. Cliché, but very useful. And since you don't need to really get into their background, as they are there for to get things kicked off and then they can fade back into the background, they make for a great little extra.

By applying these characters liberally, you can create a world that is more detailed than one that just holds the characters. It's neat to have powerful well-developed characters, but you need more than that in order to really have fun with the comic! You need the extras to fill things out, so take advantage of them.

Using Extras To Effect

If extras are those characters that are just there to provide filler, you will have those that perform specific tasks that show up all the time, but aren't part of the main cast. The perfect example of this is Nurse Joy and her infinite sisters from the Pokemon universe; every town has one, and her function is to merely heal pokemon and show how big of a pervert Brock is. Every video game has them: The NPC who is there for a specific function and that's it. There's no real need to flesh them out beyond the need to make them seem human; they are just part of the background.

Consider how many characters you have that are there just to provide information, a literal font of information. The font is just an extra; his or her identity changes each time, and the actual person doesn't matter. That is, it's a generic seer, a thug found in a bar, or just a random someone you pick every time you need a specific type of information dispersed. In this situation, the character doesn't matter, and so he's still just an extra. Nonetheless, they provide an important function in making sure that either your characters or audience have the information that they need.

Extras also show that your characters have real effects on the world. By having a real person having been affected by the characters' actions, you show that your world has depth. And in order to do this you need recurring extras. If your characters eliminate hunger, you need to show that someone who was famished is enjoying a good meal; it really brings home the point

that they have done something (eliminated hunger) and that it has had an effect (people are eating). By the same token you can use an extra to show the effects of a devastating even more effectively than by using a main character to comment on the situation; nothing says "the farm was wrecked" quite like showing a little kid with a torn clothes, a grimy face, and tear down one cheek.

In cartoons, recurring extras are used extensively. You have the poor boy who the hero treats with respect who ends up saving the hero's life (usually as a sacrifice). There is the mother of six that has adopted the heroine, usually for succor. And don't forget the caravan owner that seems to be everywhere...

A recurring extra should never become an actual permanent character; occasionally you can highlight them, using them as a plot hook in order to get a character into the story, but the character should then disappear into the woodwork. They should only show up when you need someone from the world to show that your characters are having an effect; bring them up early in the story, and then when the effect has occurred. You can show the character as events change things, but don't get too crazy with showing the character; he may be a human being, but he's still just part of the background.

Keep in mind that he's there just to create some kind of sympathy and to show how important the character is; he's not there to add to your cast, but how your cast is perceived. Sometimes it's hard to create sympathy for your characters; they may be extreme anti-heroes, cold, or extremely professional and are thus unable to truly interact with other characters, and so showing the human side of your characters is difficult. By creating an extra that shows that the characters are human, and that the character is cold for a reason, you create a little more sympathy for your

characters. Without that human touch, your comic just doesn't have any relation to your audience. And without that touch, your comic just won't become popular. And you want to become popular, right?

Consider, for example, the standard situation where the hero walks away from a violent scene and the cop who sees him just lets him pass, maybe with a quick salute. With one interaction you show that the hero is seen as heroic, even if what he does isn't, and that puts the hero's action in a different light. Consider how a waiter treats the hero: If the waiter is rude or condescending it shows that the character is considered trash while if the same waiter acts just too politely then we know the person is a great tipper. Your extras can be used to show a lot of neat details without you having to say anything; that's what your extras are for.

So remember those single mothers with large families, roaming caravan owners, and sacrificial urchins; you may need them!

The Importance of a Good Pit Crew

In racing, the pit crew is the group of people that makes sure that the racer can continue racing: They make sure that the car is maintained, that the racer is fed, and that the racer never gives up. Without the pit crew, the racer might do well for a good part of the race, but can't possibly last the entire length of the race. They may never be recognized by the fans but without them the driver would never be able to really race.

The pit crew are a step up from your flavor characters. These are characters that do important things, and not just help define your setting. These characters are the ones that not only provide a service for the main character(s), but also act as occasional

confidante, friend, and even lover. They not only make sure that the little details are taken care of, such as meals fixed, armored suits cleaned, and secret lairs maintained, but also that the wounds are properly cleaned and that there is always a shoulder to cry on. In short, they allow the main character to keep going and not just invent a new form of building diving.

Consider Alfred Pennyworth. Alfred not only helps define Batman's world (Bruce Wayne is rich, so of course he has a butler), he also makes sure that equipment works, deflects the occasional busybody, and even helps Batman do research. He has also acted as Batman's conscience, and has been one of the few people that has stood up to Batman and told him off. Alfred is probably as close to an uncle as Batman has ever had. Without Alfred not only does Batman's world fall apart but it would become a much more dreary existence.

Commissioner Gordon is another interesting supporting character. Besides giving Batman a somewhat legitimate official backing (Batman has been deputized more than a few times), as well as access to some information that even the Batman has no access to, Commissioner Gordon has also stood up to Batman (yes, it can be done!), as well as provided some plot hooks. It helps that they have an established friendship, and have even shared important events in each others' lives.

How about Mary Jane Watson? Peter Parker needs someone to keep him grounded; you can't go up against one of the nastiest rogue galleries in all of comicdom without having someone ground you. Mary Jane may not have many contacts, may not have any powers, and may be one of the weakest wives ever, but she does something that no other wife in the comics can do: She keeps one of the most above-average heroes average. And that's no small accomplishment when you realize that Spider-Man has

arguably one of the most eclectic rogues gallery of any established hero (it includes psycopaths, heroes, shape-changers, magical beings, and true multiple personalities).

May as well through Lex Luthor into the mix (ever notice how many double-L's there are in Superman's life [Lana Lang, Lois Lane, Lex Luther, Lara-El]?). An unlikely supporting character if there was one, Lex has shown not only the weaknesses of the Man of Steel, as well as his strengths. By taking one of the most mercenary personalities ever and adding in ambition and a megalomania that knows no bounds, Lex acts as Supes' best foil; because he adds so much to Superman, it's hard to imagine Superman without his dark shadow. It's because of how tied the two of them are, as well as how much The Businessman defines the Boy Scout, that it can be argued that Lex is more of a supporting character than arch-villain.

In short, a supporting character can add another dimension to your character by allowing him to be human. They allow him to mess up, and be called on it. They become just as vital to our perception to the character as what they wear, do, or say, and even become our friends and examples of what we can do (I wonder how many police chiefs have modeled themselves on Jim Gordon or businessman wish they could be Lex?). They show that the hero has someone to hang with, and just be human (or as human as some of these people get). Ultimately, they represent aspects of the character that they support, and in such a way that they help to ensure the longevity of the comic, possibly for the long haul.

Who Is In Your Pit Crew

The pit crew's composition is important, as it defines what is important to the character. The character is a rebel? Then you need a strong leader for him to rebel against. He's fighting for the

people? Then don't forget to include a sidekick as a representative of those people. Here are your basic five pit crew members, and what they can do for your hero(es). Oh, and I'm going to pick on Batman, simply because he has arguably one of the largest pit crews of just about any hero ("I work alone", my butt).

Love Interest: Romance is good; it provides a reason for the hero to do something (protect the love interest, get something for the love interest (to heal some weird disease, to prove his love. or just to show off), can provide conflict (either romantic issues or because the couple is having problems), and connects the hero to the setting (the love interest should not only be representative of the setting but can also provide updates on any crisis that you have going on and provide an added poignancy). Bruce has a long list of romantic interests, and they have provided their own fun, ranging from hiding his secret identity (Vicki Vale), conflict of interest (Selina Kyle, aka Catwoman), or even your basic "Her Dad, My Arch-Villain" (Talia). Note that they have each allowed some examination into the world of Batman, or even Bruce Wayne, providing Batman not only a great romance but the writer a way to play with some of the themes of the Batman comic (Vale and the problems of secret identities, Catwoman and the dirty underbelly of Gotham, and Talia and what makes a villain).

Superior: Arguably the weakest pit crew member, the superior is whoever the hero reports to and who tells the hero that where he will be going. A great character in the right circumstances, too many weak writers create a total nimrod; in essence, the superior is there mostly to show why the military or corporate sucks (note that I'm not saying that a superior can't be used to show how dark the world is, just keep in mind to keep a fine line). However, if used correctly, the superior allows for visible character growth (in terms of promotions, awards, and raises/bonuses), but also

things like fun or more important assignments as well as respect. Mostly useful towards the beginning of the comic, the superior should be shifted to mentor at some point, but can also be a sidekick or love interest, or even a retainer (weirder things have happened!).

Although it could be argued that he has no superior, Commissioner Gordon was effectively one at one point (as the Batman was obligated to uphold his status as deputy), or whoever was in charge of the JLA/JLI (as a member (depending on the situation) Batman is somewhat obligated to put in some time helping out). In each of these cases Batman has had to bow to someone else in order to get the job done, however temporarily, and was able to garner greater respect for doing so. Even today Batman knows when to let someone else take lead and it has made for some great stories.

Mentor: The hero needed to gain his skills from someone, and the mentor is that someone. Besides giving the hero a reason to prove himself, the mentor also allows for serious character development (demonstrating that the character is growing from student to master himself, for example). The mentor also provides an excuse for training scenes, which seem to be popular in comics with a martial arts theme. The mentor can also send the hero on quests, either for the group that the character serves, or for personal reasons (and they don't need to be serious; Inu Yasha has a monk send his protege on a quest for a special kind of sake). The mentor can also get away with a special kind of exposition: The field report (a briefing on what is basically happening), which is probably one of the least annoying methods of exposition ever created.

Although few of Bruce's mentors have been shown, they have popped up from time to time. They have allowed us to see the

Jochim-Character Building

unique personalities that have shaped the Dark Knight as well as show that he not only has mastered his skills but still has a ways to go. They have also shown how people can fall and how they redeem themselves. In short, even if they aren't part of the comic they have nonetheless given him a deeper backstory, shown development, and emphasized the themes of the comic.

Sidekick: The reverse of the mentor, the sidekick is a character that the hero is training, or as a surrogate son or daughter. The sidekick is best used to give the strip a comedy relief and to lighten an otherwise dark strip, but can also be used to drop a note of seriousness as needed. The sidekick also acts as the hero's conscience, as well as someone to bounce strategy off of, and a set of long-distance hands. The sidekick usually has a diminished set of skills or powers based off the hero, but this doesn't always need to be the case (in fact, if you wanted to give the hero a shift in perspective, make his sidekick someone who is there to learn more of the attitude than actual skills, or to chronicle the hero's journey). And keep in mind that the sidekick doesn't need to have respect for the hero (especially at the beginning); it can be interesting to have a sidekick that actually hates the hero yet is forced somehow to be protected or trained by the hero.

This includes any member of the Bat-Family (the various Robins, Nightwing, Batgirl, Spoiler, etc.); the guy likes taking in strays. Each of them have contributed something different to the mythos, ranging from the Prodigal Son of Grayson, the Faithful Son of Drake, and the Rebellious Son of Todd. Barbara Gordon learned a lot of her crime-fighting skills from him, and Spoiler learned how to interact with humanity thanks to him. Even Damian has been in an interesting addition as the heir to the kingdom. Interestingly, each has acted as a squire in turn adding to the Dark Knight image as each has had to find their own cause and act on it. They have also become leaders in their own rights, taking up the mantle of knight as leader in combat in their own

time.

Retainer: This covers a lot of evils, but the essentials are the same: The person has skills that are vital to the hero, usually ones that the hero doesn't possess himself (such as computer, healing, or administrative skills), skills or abilities that are useful enough to replicate (such as combat skills or super-powers (a lot of bricks start off this way), or even just a different perspective (a civilian in a military group, an observer who can't keep his observations to himself, or even a naïve or cynical character). Keep in mind that this includes soldiers under the command of the hero, people that the hero has hired, or even people that just follow the hero around (those silly friend and companions-in-arms things).

Alfred is an obvious example, but so is Azrael (who was hired to take his place prior to going, well, bats). Also, the Sons of Batman (from the Dark Knight Returns) would definitely count as well. Lucious Fox definitely counts, adding his business skills to the situation. It can be argued that the members of Batman, Incorporated, are retainers as they are both soldiers in the cause as well as individuals with their own skills and experience that make them formidable on their own.

The bottom line is that as each member of the pit crew adds to the ability of the driver to stay in the race, the pit crew of the comic enables the comic to stay around. Maintain and increase your pit crew if you really want to see your comic go places. You don't need a lot of them: Bond only has two letters, and he does pretty good. Nonetheless, make sure you have someone to back the main character and your comic will do great.

The Importance of a Good Sidekick

The sidekick is another major character that needs to explored. As an extension of the hero, the sidekick acts as an interesting character, especially if handled correctly. They can be a valuable member of the supporting case as well as allow exploration of the comic's themes. They can also allow for some of the lighter scenes as well as allow some for some of the exposition (the main character has someone to explain things to and thus inform the reader indirectly). The sidekick thus does a lot of heavy lifting if used right.

There are three basic types of sidekicks. There apprentice heroes, who are trying to learn how to be a hero from a hero (Robin is obviously the stereotype here). Then there is the "accidental" sidekick; this sidekick always seem to be able to be in a position to help the hero, even though he definitely shouldn't be there (Penny and Brain, for example). Lastly, there is the character that could be a hero in his or her own right, but is somehow tied to the hero (Black Canary as regards Green Arrow, although that could be debated).

Each type fulfills a different need, and by exploring that need you can determine which sidekick you should strive towards. The obvious quicky note: You don't need a sidekick. They fill very specific literary needs, and so they aren't right for everyone. Also, don't make the mistake of assuming that everyone likes the idea of a sidekick; when sidekicks were originally introduced as a sort of avatar for the boys that read comics back in the 1940s, the concept was despised (every boy wanted to be Batman but no one wanted to be Robin). Bear that in mind when you debate one.

The apprentice is the sidekick of choice, especially among male heroes. The apprentice provides a continuation of sorts, and

represents the hero's legacy. He is responsible for training the sidekick, and the sidekick becomes an extension of the hero. This doesn't mean that the sidekick can't evolve; rather, that when the hero evolves, the sidekick will be the physical manifestation of that. For example, when Batman was finally able to let go of his past, Dick Grayson was allowed to become Nightwing and become a hero in his own right. Of course, it was quickly realized that Batman needed Robin (without Robin, he became depressed and focused too much on his work; he needed Robin to keep him balanced), and so a new one was quickly found (of course, Jason Todd didn't work out, so Timothy Drake was brought in).

The apprentice is best used when the hero needs to have some sort of symbolic reminder of what he is fighting for, and has some deep issues when it comes to legacy or family. The sidekick is the physical manifestation of the hero's dreams of the future, and provides a link to the past. In short, this particular sidekick is best used as a symbol, but with a conflicting personality to its hero, and abilities based off the heroes (to further enhance the symbolism).

The accidental sidekick is straight comedy relief. The hero keeps getting himself into weird situations, and needs to either be rescued or has to have some luck fall his way; the accidental sidekick provides that escape or luck as needed. The idea is to demonstrate that the hero isn't the end all/be all, and that he has some definite flaws. Penny and Brain are the examples here; Inspector Gadget is always getting himself into danger, and being extracted or rescued by Brain, even as Penny solves the case and provides back-up for her uncle. In pulp, Tonto is probably a good analogue, as he is there to merely provide an extra set of hands for the Lone Ranger but nonetheless keeps showing how limited the Lone Ranger really is; Tonto has rescued the guy in the mask way too often. As noted, only use this sidekick when you need comedy relief; it sucks if used for serious reasons.

The equal is the weird one. This character is the hero's inferior only in rank; in all other ways, she is the character's equal or superior. There's a lot of reasons for this, such as some sort of binding spell, the hero has something she needs, or that the sidekick is being punished; the bottom line is that the sidekick is subservient to the hero. Although it can be used for comedy relief, the best way is to show that the hero is still learning his way around, and that the sidekick is going to show him the way; a shaman or pathfinder if you will. This also works for the love interest; it allows her to show up and help without being tied to the comic.

At any rate, have fun with sidekicks; used correctly, they can add so much to your comic. Used wrong, however, and they tend to kill it. So if you do want to use them figure out how they work in your comic and have fun with them, and use them for the tools that they are.

Having Fun Abusing the Sidekick

Sidekicks are the most abused characters in comicdom. As such, it helps to keep in mind that they are useful. They can fulfill a number of roles that makes telling a story that much more easier even as they add another character you need to worry about. Nonetheless, those roles need to be looked at so that you can see some of the ways they make life easier for you.

Your hero can't be everywhere, and can't do everything. Worse, he can't talk to himself. Yeah, he clone himself and talk to himself or he can be suffering from some sort psychological problems, but that doesn't work from a dramatic perspective; without limits your character can get very boring very quickly, and insane characters can't really be understood (and if they are,

are they insane?). Sometimes you need someone to talk to and to do things off-screen; having someone you ask the right questions and act as extra pair of hands can sometimes be a good thing.

The sidekick takes up some of this slack. The sidekick can do things that the hero can't, and allows the hero to think things out when things have gotten rough. The sidekick can also act as a medic or seamstress, for those characters that don't regenerate or have self-repairing costumes. He can also set needed appointments, and remind the hero of those appointments. He can also make sure that the lair is clean and equipment maintained. Like the apprentice of old, the sidekick is capable of doing things you don't want to see the hero doing, either because it's just not heroic or it would feel weird.

At the same time, the sidekick needs his own maintenance. He needs the slap on the back, the dint of recognition, and it helps to be paid every so often. The sidekick has his own goals, which, just because they align themselves with the hero, doesn't mean that they are the same or that they don't diverge. The sidekick has to be allowed to pursue those goals, and even have a live of his own that doesn't involve the hero. This especially applies to teenagers, who not only have to worry about school and the other sex but may have their own future plans. At some point the sidekick has to step out from thehero's shadow.

And that's an important point that needs to be considered here: The sidekick has to be able to go to college, have a significant other, or just go to the local casino every so often. Their existence need not be defined by the hero, and that serving as a sidekick may just be some form of community service, a way for a would-be hero to learn the ropes before becoming a hero themselves, or as a way to help someone do something that they could not. Some of them do it for baser reasons, such as revenge, lust, or even

pay; those motivations need to be considered just as much as higher motivations.

The sidekick can also add to the drama, but I highly suggest you debate putting the sidekick in danger more often than you really need to. The sidekick may be an easy target for the villains to kidnap and endanger, but if it's more than a few times then it loses its punch. Not only does it question the competence of your hero and what the sidekick has learned, but it also questions your own skill as a writer (if the only way you can make things more interesting is to imperil the sidekick, then you may want to add to your toolbox). You can only imperil the same character so often before you need to kill him just to make the point that the hero does fail sometimes.

The sidekick should be used to show why the hero does what he does, but he should also be used to plumb the depths of your world by occasionally getting away from the hero. The sidekick should be something that you have fun with; if he is just the exposition monkey then it may be time to drop the sidekick and work with a different character. Nonetheless, the sidekick isn't necessarily a bad character, especially if you have some fun with him.

Some Notes On The Romantic Lead

One of the hard parts about writing a romance is that the most successful romances are hard to write. That is, they are a lot harder to write than the most complicated fight; there are a lot of things that need to work right, and they can drive even the best writers crazy. However, when they work they are so worth it; nothing makes for a sympathetic hero as having a hero involved in a great romance. They can also be a great way to evolve the character, as they allow for a natural evolution from one stage of development to another, from the character starting out to

establishing roots to allowing for the future.

It bears noting that this does not assume a strictly heterosexual, same-species romance. Comics being comics, these notes apply equally well to any romantic relationship regardless of the gender or species of those involved. The only assumption that we're working on is that the relationship is a romantic one; a more lust-based one is beyond the scope of these notes.

1) They need to support each other. The couple needs to learn that they can depend on each other, that they have each other's backs. The best example here is that of Reed and Susan Richards, who have shown that their relationship is based on more than mere attraction. The two have been through thick and thin, and even finding a copy of Reed's journal where he had notes of the tragic accident that gave them their powers; when the journal was eventually to have written by Doom she put him in his place, but didn't doubt Reed for a second. Conversely, Reed saw her through her Malice episode with their relationship becoming stronger as it survives every test.

2) They need to learn that each is the complement of the other. If one is a ranged specialist, the other is a melee master; they cover areas that the other doesn't. This includes more than just things like combat, social skills, or even cooking; the couple needs to realize that where one fails, the other succeeds. They need to be able to handle a wider range of challenges together than alone; otherwise, there is no reason to match them up as a couple. This is why the Cyclops/Phoenix romance works; Jean may have a thousand ways to kick butt, but she needs Scott's tactical skill to make the most of it. It doesn't hurt that Scott isn't exactly a lightweight on his own, having basically one of the biggest guns on the planet and a plethora of skills he can bring to bear on any problem. In short, her raw power is complemented by Scott's

skills, just as Scott needs her to keep him grounded.

3) They need to be independent of each other. This goes back to the relationship has to be of equals; if one is dependent on the other, that's a great Harlequin romance, but it's boring to comics readers. We don't like heroes that need to be bailed out on a regular basis; the damsel in distress may be great for other genres, but it's sort of lame for readers who expect everyone to pull their weight. This is what made the She-Hulk/Wyatt Wingfoot romance problematical; Wyatt needed some firepower to equal She-Hulk. However, with his access to SHIELD firepower, resources, and social connections, he nicely complemented her physical prowess and legal skills. Either one can handle a variety of situations, and can help the other fight battles that are scaled to the other person. If one needs the other to function, it's time to debate the pairing.

4) They need to be bring something out of the other person. This is why Peter Parker and Mary Jane Watson worked: Parker was more focused and willing to compromise with Mary Jane around, while Parker brought out her more maternal side and she lost a lot of her flightiness. That is, together they became a lot more focused and became a lot more mature. This means that Parker was a little more professional as Spider-Man and Mary Jane retired as a model, but they also found that they could more than they had expected; their futures were brighter together than separate.

5) Each needs to bring something to the relationship. The relationship needs to be between equals, or at least set up so that both brings something to the table. This is why Clark Kent and Lois Lane works so well: Lois not only keeps Kent grounded, but is one of the few people who can actually make him back down. It may sound like a minor thing but when your boyfriend is one

of the most powerful people on the planet that is no mean trick. She also brings all of her contacts and skills, which are formidable on their own. Thus, while Lois seems to be outmatched by her Kryptonian lover, she definitely brings something to the table.

These tips should help you write some pretty solid romances. Just remember that the romance has to do something for each person or it will turn pretty toxic pretty quick. While this can make for a great way to create villains, try to keep it straight and the rewards from the relationship will be well worth the investment in time.

How Not To Refrigerate Women

One of the more basic problems you need to avoid when it comes to romance in putting women in refrigerators. This was originally caused because when writers needed to create some cheap empathy they would kill off the hero's lover; you couldn't kill off the sidekick because he represented the future of the hero and any of the others associated with the hero just wouldn't provide the necessary juice as the audience was well too aware that they could be replaced far too easy. As such the lover was the one that bit it. Suffice to say that as the lover was usually female this was not seen as good thing by feminists.

Note that this is not just bad things happening to heroines; bad things tend to happen to all heroes regardless of sex. You fight on the front lines or otherwise make yourself a target you're bound to suffer some serious injuries. And, sure: If you're the close one of a hero you may as well be wearing a target on your back . However, this is nonetheless a problem and one that you need to be aware of; fortunately there are some pretty basic fixes.

The simplest version is: Don't introduce new lovers or even

friends just to kill them off. Have you noticed that you can tell who is going to die on TV when some new love interest is introduced? If it happens too often, then your fans will start asking why your hero hasn't committed suicide or at least suffering from intense depression ("Every time I meet someone interesting, they seem to die horribly. I need a drink.").

The solution is to make sure that you have a stable of interesting characters. You need to make all of your characters interesting, and not just those that will be getting a lot of screen time. All of your characters need to have interesting backgrounds, depth, and a little extra dialogue; they need to have just as much as detail as your main characters, even if you never explore that in the script itself. It's not wasted effort; it gives you a much better handle on the situation when you write it, and that's worth any effort.

If you do this, then you can spread the pain around; whoever you hit with the damage will affect the reader in the way you want them to be affect: Deep and painfully. Also, because readers associate with background characters more, especially if they have been well-written, you can get the same dramatic effect from one of their deaths as well. I imagine that if J. Jonah Jameson died, you can bet that there would be a lot of people not happy with the writers.

In short, if you want to be taken seriously, then you need to take your characters seriously. Do that, and you really have no limits to what you can do. Don't, and you're just writing the usual, boring pablum; do you really want to about baby food or a rich seven-course meal? And that means that you should never introduce a character just to kill them off; it's lazy writing and your audience is likely to hate you for it. As such, only kill characters off that you have taken time to establish; it's more fun and it really hits the reader where it hurts. But stop refrigerating

the women; it's something that needs to stop.

The Pragmatism of Organizations

Characters tend to organize themselves into organizations, and so it's not a bad idea to look at them. The big one is how the organization falls on the pragmatic/moral axis, and that will effect your main characters in terms of how they deal with the bad guys, and how the bad guys deal with them. This makes it well worth looking into.

Pragmatism/Moralism refers to the organization's moral standing relative to the general populace, and to what degree those morals are implemented. A pragmatic organization will tend towards dealing with any situation as expeditious as possible, and cares more about the results than the context. They have no problems using assassination, blackmail, and discrediting a target in order to accomplish their goals. It should be noted that such an organization can have moral reasons for this stance; MI6 is willing to do almost anything in defense of England, for example. New agents' conflicts are usually those involving their conscience ("Would you kill a four-year-old girl in order to save lives?"), whereas older agents are more worried if they still have a conscience; agents of such an organization are going to be world-weary and have some sort of vice that they engage in in order to feel alive. Sort of explains why James Bond has that issue with beautiful women...

A moralistic organization, however, is more interested in maintaining the high ground. The agents are going to tend to be more intelligent than more pragmatic agents, but they are also going to have more hurdles to deal with; after all, they'll need to allow for the various rights of the target, and will generally be seen as softer than more pragmatic agents. This means that they

need to more circumspect than pragmatic agents, and will actually use the threat of using a more pragmatic organization to stop bad guys ("Deal with us and you might actually live!"). Also, they are more likely to use devices that have stunning options to slow down targets, and will gather more detailed evidence; the more pragmatic agent would just figure out a reason to shoot. Besides dealing with targets that want to kill them, all agents will have conflicts based on their conscience; besides having to deal with innocent victims, they will have to deal with possibly letting a dangerous criminal go. Suffice to say, some have the same addiction problems as pragmatic agents, just due to stress.

Although the stereotype is to use pragmatic organizations in dark stories and moralistic ones in comedies, they can easily be switched. The major concern you should have is what kind of point you are trying to make. A pragmatic organization is great if you are trying to make a point about people doing whatever they need to do, but can also make the point that sometimes you need to do hinky things in order to preserve things. It can also be used to show what happens when an organization takes itself too seriously.

A moralistic organization can be used to show that everyone has rights, and those rights take precedence over the group. It can also be used to point out that a rights-based enforcement system is ludicrous. Of course, if you just want a really friendly police system, this works as well. However, don't make the mistake that this can be a shallow system; sometimes there are good reasons for why it's been set up, and those reasons are very good.

Of course, you can always go with a middle ground (which is where most organizations seem to be), in which case your organization is basically one that allows rights whenever

possible, but isn't afraid to shoot. You can also mix and match, where each agent makes their own decision on how pragmatic they are, or have an organization that has a specific unit that's very pragmatic, but the rest of the organization tends towards moralistic ends.

Short form: Main characters from a moralistic agency will need to deal with severe reprimands when it comes to killing or even injuring the bad guys and the bad guys are more likely to run when possible. Conversely, a pragmatic agency encourages killing bad guys and so they are more likely to surrender. This in turn will determine how your main characters are treated, and as such its worth debating where your organizations sit.

What the Support of an Organization Will Get You

Not every organization supports its agents the same, and sometimes there are even levels of access within the same organization. This level of support needs to be noted, even if that support basically means nothing. However, just like the other variables how well the organization supports its members can determine how you handle it.

[Caveat: This applies to how the organization treats its members in general. A hero and a villain will obviously be treated very differently, with a hero getting access to anything anyone can get him, whereas someone who is generally disliked will be lucky to get a can opener. Someone with a reputation for getting the job done while getting good press or making others feel good is obviously going to get anything he wants, to the limit of the organization's ability, whereas someone with a reputation for dead or severely partners, who just does what he wants, or is generally a jerk will have problems getting more than basic support even at the best of times. This means that the Golden

Boy (of Girl) of an agency will find all the support while the agency's Bad Boy (or Girl) will usually have problems.]

A supportive organization will find ways of supporting its members no matter what, to its limits. The reason can be pragmatic, such as military organizations; they have a job to do, and they must give their members every legitimate chance to succeed at that job. They also have to explain their budgets; if a soldier goes into a situation with minimal gear, you know someone is going to answer for it given how big military budgets get. This applies to clubs as well; you would be surprised how well a club will make sure its members are prepared when club pride is challenged, even if its resources are limited to determining the nesting habits of local birds.

A hostile organization, however, seems dedicated to messing with its members. This is either because its leadership is apathetic to its membership or has created too many bureaucratic hoops to go through. There are also organization that have become so corrupted with politics and fear of legal suits that their members have little support from an organization that is scared to do anything. Consider the Japanese police for a moment; they need to be polite to everyone, they most likely have links to local gangs, and there are complications based on familial relations. It may not seem hostile, but it meets our definition here, as all of those features make it notoriously unwilling to do anything unless it has to. Little wonder that the yakuza end up settling so many problems!

The irony of this situation is that the lighter the universe, the more hostile an organization is going to be towards its own members, especially if that organization is law-enforcement, as politics and legal issues throw the organization into a quagmire. Conversely, the darker the universe, the more likely the organization is going to be supportive, as it realizes that its power relies on a solid front, so offenders are dealt with whatever force can be summoned against them. This is why cultists are

scarier than cops; the common goal with no legal limitations versus the legal quagmire gives the cultists an edge.

The lesson for writers? The local bird club can be scary in a noirish environment, as everyone supports one another, which includes all that firepower that seems to float around those universes despite draconic laws, especially when you realize that the individual members tend to be rich, and therefore have resources. Conversely, an order of knights is going to find it hard to deal with a dragon when they know that they are going to have to deal with destruction of property suits if they do anything to save the citizenry. Getting people together is never easy...

Sinister Organizations Are So Much Fun

A fun axis to look at is the sinister/friendly one. A sinister organization will tend to do things to control its people, whereas the friendly will seek to help them. Although all organizations seek to control and help the people of which is it a part, this addresses which is more important to the organization.

A sinister organization is interested in using whatever power it has to control as much of the group it is part of as possible. Consider how government law-enforcement organizations are treated in cyber-punk: The CIA goes around assassinating public figures that are leading the United States away from military intervention while toppling countries in order to foment chaos among its enemies. The FBI is not just an investigatory agency but regularly arrests those that it sees as saying or doing anything essentially un-American; it is almost as if J. Edgar Hoover never died. These organizations are not just interested in doing their job, but using their power to control how Americans deal with the world.

Friendly organizations, on the other hand, stay in the background. Although it can be argued that they are using more subtle controls, they are there to help the people that they are

created by. An example of this is the USDA; although it can be argued that it is a tool of other, more sinister forces, most of the food safety reforms come from the USDA, as well as virtual libraries on almost any agricultural or nutritional topic that can be imagined. It is hard to see the USDA as a sinister in and of itself, and it is usually portrayed either helpful or naïve.

Story-wise, the difference defines how dark or light the universe is. Dark universes are full of sinister organizations, where every organization is full of corrupt leaders doing their best to hold onto whatever power they have, boring administrators doing little more than filling out the necessary paperwork, and highly trained and deadly agents enforcing the will of those organizations. There is a reason why darker worlds rarely focus on more than one organization; although their powers may be different on paper, they are all ultimately of the same dark stripe, and only the name matters. You just need a name to slap on an organization, and you're good.

Friendly organizations, however, are vastly different, and the name is of actual importance. Although an organization may have its enforcement arm, it usually tries to talk someone down, and bland agents are dispatched to investigate the situation first. Eventually the investigation will be completed, and the suspect will either be released or taken into custody. But all of this will be done by the book, and no one will really be offended by the investigation; it is just the agency doing its job.

Of course, specific groups within an organization can be a different axis than the majority of an organization, and an organization can always act differently when its needs dictate. providing for some nice conflicts. Give those USDA agents some machine guns to deal with a hostile corporation and things get a lot more interesting. If you really want to mess with your cyberpunk street samurais, have a local corp be extremely friendly; they will wonder when the corp turns against them. Just be aware of the axis and have some serious fun with it.

COSTUMES

While it may seem weird that there is so much space devoted to how a character looks, keep in mind that this is a visual medium, and so it does pay to at least think about the characters look. Because there are so many different considerations to debate when it comes to how a character looks and even world-building issues when it comes to equipment, a writer needs to at least debate some of these topics, and they can be an actually fun to think about. However, they can also be some fun topics to discuss with your artist and the source of many headaches. So sit back, relax, and buckle in for some interesting ideas.

Basic Considerations of Costume Design

An illustrator has a lot of issues to worry about, and costume design can be the biggest problem. The character designs are not just important for the comic itself, but for marketing, branding, and even sections of the website. There are some basic considerations that need to be taken care of so here's some ideas.

An important consideration: Every detail needs to be debated, especially if you are doing a humor comic. You can get away with some skimpy designs, especially compared to a lot of other comics, but for those that have some serious designs make sure that you know the genres involved. That applies especially to comedy as the costumes should add to the humor: If you're making fun of 1990s superheroes, a hero with its of pouches and pointed feet with a ridiculously buffed body and huge guns needs

to be part of it. Keep the conventions of your genre in mind and your comic will look great.

It's a great idea to make sure that the costumes are functional as well as great looking. This is a criticism leveled at most science fiction and fantasy comics, but worth bearing in mind for other genres as well. The outfit needs to work with the person's profession as well as the local weather; there is a reason that a beekeeper is dressed so thickly and Pacific Islanders wear so little. If the character does a lot of traveling the character will tend to cover a lot of skin, and the clothes will also be loose; this is because a traveler has to deal with a lot of cultures (a lot of which have issues with bare skin) but needs to be comfortable. The clothes have to look right for the character and what the character does.

Social class also needs to be allowed for. A poor character's clothes are going to have more wear than a rich character's, and the rich person will also tend to have more decoration than a poor person. The key word in that last sentence is "decoration"; it can mean scrolling and piping as well as jewelry, especially as some cultures do not use jewelry. That also applies to any equipment the character carries, and especially any weapons, especially as different social castes may have different weapons: A rich person's weapons will be effective more stylish (such as fencing foils), a poor person's will be more geared for self-defense and simplicity (daggers), while the middle class is more interested in function over form (longswords).

Seriously debate kilts and pants. There aren't enough men in kilts, and they make a great fashion statement for action heroes. I also think that there needs to be more women in pants; it also makes more sense for an adventurer than a dress. This is not to say that the character needs to be exclusively into kilts or pants;

they can wear pants or dresses for other functions. It would just be nice to see more of them.

Racial elements also need to be debated. A character with a tail does not need to just wear pants with a hole in them; it needs to be allowed for in the race's fashions. A winged race is unlikely to wear metal armor due to its weight, and is unlikely to wear much back armor if any. It also bears noting that a thick-skinned race is unlikely to wear much, if anything, in the way of clothes; there is just no real need for it. This applies to body decorating as well; a furred race is likely to color patches of fur rather than wear tattoos.

Body decoration needs to be seriously debated. You should not use tattoos just because they look cool; they need to serve a purpose in the world and there are sometimes social ramifications. Consider yakuza tattoos; not only are they worn by people tat need to make themselves known, but their wearers are also forbidden from some areas. In general, poorer cultures with a lot of visible skin have tattoos, merchant cultures tend to favor ostentatious displays of wealth such as jewelry, and more philosophical cultures prefer simpler clothing, especially if ostentatious displays of wealth are looked down on.

There are some cultural reason as well. Besides concentration camp survivors, tattoos have also been used to show possession (some nobles tattooed their serfs and slaves) as well as military organization (some European militia went sleeveless because their regiment information was tattooed on their left shoulder). It can also show rebellion; Amy Tan is famous for the shock of purple hair she wore to rebel against her background. This also shows up in hair styles; a mullet is rarely the sign of a rich man, while a short hair cut shows someone in the military. In Europe the rich wore long hair for the same reason rich people in China

had long finger nails; they had other people to do care for it.

The basic point is that you need to have some serious fun with character designs, and it can help you build the world at the same time. Take some time and have some fun with it. After all, with any luck these are character designs you are going to have to deal with for a while, and you had better have some very good reasons for them.

What Is It Made Of?

One of the weirder questions you may have to deal with is, "What are your clothes made of?". And no; this does not apply only to super-hero comics, but fantasy as well as horror comics. If your characters have any kind of shape-shifting or size-changing abilities, or any kind of transformative abilities such as werewolves, then you may wish to ask this question. The bottom line is that if there has to be some reason that a character who turns into flame or gains a few hundred pounds of muscle on a regular basis isn't a major customer of the local clothiers, and some sort of meta-cloth may be the answer.

Marvel Comics has a pretty good solution to this: unstable molecules. Clothing made of these molecules mimics the abilities of any wearer, allowing them to stretch, shift, or otherwise be immune to transformations of their wearers, such as turning to flame or even invisible. As the fabric in your universe may also be more resilient it could also offer a form of armor, even capable of repelling bullets.

At the other end of the spectrum White Wolf had a ritual that convert one suit to clothes that would transform along with its wearer and would disappear when he changed to a non-human form and appear back when the shifter returned to a humanoid

shape. This allows clothing to disappear, either by shifting to another universe or by melding into the character's new form and reappear unharmed when the character returns to his human form. While this is may not be great for all transforming characters, it is a good fit for a wide range of shapeshifters.

Consider also some of the more exotic options. Spider-man's symbiotic suit is a great one; prior to it becoming Venom, the suit could mimic any suit of clothes with a thought as well as mimic some of Spidey's equipment, such as his web-shooters. With Venom the suit allowed some shape-changing abilities. Similarly, in the Trinity RPG, there is the bio-evacuation suit, or BES; this organically grown suit allows its wearer to survive in space, is comfortable enough to wear under another suit of clothes, and will even pop a helmet up if you end up in space while asleep. Both suits allowed their wearers full range of their powers without interfering, and were considered part of their owners for all intents.

You may have other needs to allow for. If you have energy-based races you may need containment suits so that they can interact with flesh-beings, either because of their radiation or lack of a body. Have a feral race? The outfit needs to be tough, form-fitting, odorless in and of itself, and clasps tools tight in case its wearer runs off. And then there are the Qin of Trinity, a race of worms who rely on their human-shaped body armor to hide their individual identities from the humans they deal with.

Keep in mind that you can have fun with armor as well. "The thicker the better" will always be a good general rule, but you can always develop some sort of special cloth that absorbs impacts or deflects energy attacks. For that matter, you can use cloth that emits a force field when a weak electric current is run through it. Obviously there are no limits to what you can do with

clothing, so decide what you need it to do, and it will. So have some fun making up types of clothing and make it do what you need it to do, but remember to be consistent with how you portray it; while it solves a lot of problems you don't want it to be the cause of any continuity issues. Clothing is important, and deserves some serious thought; think it through and your readers will appreciate it.

Form versus Function

When it comes down to comic book fashion design, there are two basic camps: Form and function. Function fans believe that the best character designs should be functional, and allow the character to do what it is that they do. Form afficionados, on the hand, believe that the best costumes are a little fun and decidely fashionable. Where the fans prefer visors, boots, and armor the afficionados prefer shades, sneakers, and jackets. This is the difference between mercs on the prowl and James Bond looking for clues, with the mercs being armed and armored to the gills while Bond keeps his armament hidden.

Ignoring super-heroes and cyborgs for a moment, the issue is more than just aesthetic, even though your illustrator may disagree; there are issues of just how gritty you want your comic to look, and how dear you want human life to be. Those looking for a gritty story where human life is cheap usually ignore body armor in favor of decent fashion. Not only does it underscore that human life is cheap, but that it's more important to go out looking good than anything else.

It also makes for an important point regarding relationships: People are going to have relationships that tend to the superficial, and that are more important for the political relationships they represent than the actual relationship. Some are going to be based solely on how pretty or handsome the characters are, and will

likely last only as long either is in fashion. It also means that ugly characters are going to be easily aggravated, as the only relationships they have are those that they pay for or force. The world may be pretty, but the people are ugly.

On the other hand, if you want to show that human life is important and worth clinging on to, then put everyone in armor. The armor doesn't just act as a protection against bullets and blades; it also shows the emotional armor that people put on in order to protect them life. People are likely to not expose themselves very often, but when they do they are likely to go full bore. Relationships are going to seem forced and usually long term; once someone finds he feels comfortable with he is likely to do whatever it takes to keep that relationship. Even those that appear open are likely to keep some part of themselves hidden. This world will be filled with a lot of icebergs, where everything is chilly and there is a lot more going on then what appears.

Of course, you can mix the two approaches as desired, either on a person-by-person basis or creating a split world between those the pretty and the armored. That could make for some very interesting characters, especially as their personalities would have a very visual aspect to them. Ultimately, when you decide where you are on the armor debate, talk it over with your illustrator and see what the two of you decide. Regardless of that decision, it is one worth debating.

Spandex versus Armor

There are two schools of thought when it comes to super-hero outfits: form and function. This is also known as the dreaded Spandex versus Armor debate. This may not be a major debate for most comics; if it becomes an issue for your romance comic it's an obvious cue that divorce is not going to be an option. However, for comics with a little bit of action this can be a

serious issue.

[For the purposes of this discussion, "Spandex" means "any outfit made of a material tight enough to reveal anatomical details, usually made of (but not limited to) actual Spandex or a similar material". This also includes futuristic materials that are render the wearer invulnerable if the material happens to be skin-tight. "Armor" means "any bulky outfit designed to protect the wearer from harm"; this can include any suit of medieval armor, powered armor, or even modern military armor.]

There are a number of issues to consider here, and they are all going to come down to some interesting political debates. Putting those aside for a moment, some characters prefer Spandex, others armor; this is a matter of personal choice based on a number of factors. Generally, if the character has some degree of invulnerability (that is, he's tougher than most armors), odds are good that he's going to prefer Spandex; any armor worn is usually for show or image more than anything else. Characters that prefer stealth or mobility will generally also prefer Spandex as armor tends to slow them down. This is also the choice for those who like to flaunt their bodies; being a hero leading an active lifestyle does have its perks and one of those is a great body.

On the other hand, characters espousing knightly ideals or those that are all-too-aware of their mortality are going to prefer armor. Armor is also the choice of the tech-based character as it allows them to show off more of their technology as well protect it. Characters with military or police origins also prefer armor, recognizing that it not only provides armor but also because it engenders respect. Armor is also used by those with handicaps in order to provide mobility. For those with a secret identity to protect, a good suit of armor obscures physical features as well

as facial ones, making it harder to identify the character.

You also need to decide on which side of the objectification war you are on. Putting a woman in Spandex is considered exploitative in some circles; it creates the idea that the character does not exist past her physical attributes and is a way to diminish any other value she may have. Even if you don't see it that way, be aware that some people do.

There is, of course, a third option which seems to be forgotten: clothing. Usually used by Asia or Arabian characters, the character wears actual clothing. This can be as simple as a pair of jeans and a hoodie all the way to something out of the Arabian Knights. This can also include characters that go around in military dress, specifically camouflage or dress uniforms. It can be used as a way to hide identity as it is easier to lose a uniformed character in a crowd. Although usually used to accentuate the character's origins, it also allows an outfit that isn't as embarrassing as Spandex or as encumbering as armor. It can be used to show a character that is somewhat guarded but still allows certain aspects of their personality through.

Regardless of which mode you choose, make sure that it represents the character well, and fits within the theme of your comic. The proper use of armor or Spandex, or even clothing, can speak volumes about your comic and says even more about your characters. As such make the decision carefully but have some fun with it; this is your chance to play fashion designer to effect.

The Perennial Debate of Good Costumes
Costume design will always be one of those perennial debates. Which colors to use, is there be a team logo, should the costumes

even be themed makes for some interesting questions. All of these decisions and more need to be decided before pen hits paper or you will waste a lot of time, paper, and effort on costumes you know you won't use. So let's work through the design process a bit.

The biggie is whether or not uniforms will be in play. If you're working on a super-hero team, a military group, or even a religious organization then the use of uniforms is assumed to at least some degree, and you just need to decide on what the uniform will look like. If you are doing a school comic, uniforms not only allow you to play with authority issues but can also make drawing a lot easier. If you are dealing with a group where some uniformity is required, then uniforms are usually the best way to go as it helps to ground your comic in reality before you take it to some weird places.

However, even if you want t demonstrate that everyone are independent thinkers, you may want to debate the concept of uniforms: When everyone wears the same thing it not only shows that they are alike in thought, but it is also easier to differentiate between groups. Even if the uniform is a general sense of dress (such as similar colors or obvious emblems) rather than identical clothes it will help to unify a given group of characters. If you have a large group of characters and you have them divided into a group of factions, giving them an identical or similar appearance gives you access to a visual shorthand that helps readers identify who belongs to which group easily. And anything that makes it easier for the reader is a bonus.

The group styles can be defined as loosely or as exactly as you need. If one group does T-shirts and jeans, another can do hoodies and slacks. You can even point out that certain groups wear a specific kind of T-shirt or jeans, be they their own groups

or a sub-division of another group. Keep in mind that groups have defined the difference between itself and another by as little as what animal they wore on their shirts, so you have a lot of room to play with. Just remember that when you define a group's clothing you need to stick with it; a change in clothing should be allowed only for a significant change in the group.

[Quick Aside: This can also be a great way to strengthen your story and create debate among readers. If a character switches factions then obviously his mode of dress will switch as well. Characters belonging to multiple factions will combine styles, just as characters belonging to one faction while being sympathetic to another will include some of that style in their dress. This can also create some discussion if a character known to be one in faction wears the clothing of another; if a character wears a set of Bull earrings but is part of the Bear group it can be great foreshadowing of later events. Clothing can be a scary tool in the right hands.]

Even if you do go with uniforms, keep in mind that there are a lot of areas for personal options. Even if you decide to use military uniforms, you have a lot of play beyond branch and rank insignia. The condition of clothes, jewelry worn, even something as simple as sleeve length (even a matter of inches, such as a sleeve worn just above the wrist versus one worn just below) can make a huge difference between two characters. Even if there is a base uniform, a character can modify it to their liking and those modifications can tell a lot about the character. When they first started out in the New Mutants, Sam "Cannonball" Guthrie wore the default uniform even if it was a bit loose and wrinkly on him while Danielle "Mirage" Moonstar added all sorts of Cherokee flourishes to her tight uniform. Doug "Cypher" Ramsey wore his uniform tight (when he wore it; for a shy character he seemed to lose parts of his uniform frequently) and it seemed brighter than average while Rahne "Wolfsbane" Sinclair wore hers tight but

the colors were more muted than other uniforms. That variety within just four outfits can be expanded as needed. It's just a matter of realizing that a uniform can be an expression of the character and his faction and then running with it.

In short, if you want to show unity among your team, uniforms are the way to go. And they do not all need to be identical, allowing you to have some fun with the concept.

Fun With Tattoos

If you want to see an illustrator twitch merely suggest tattoos. While they may sound cool, they add an extra level of difficulty to drawing the character as they must only not be designed to serve the character well but must be designed so as to be replicated easily enough. This is sort of why tribal tattoos are so common; they can be easily replicated without thinking them through too much. However, given the uses you can put tattoos to they may be worth the glares and twitching of your artist.

Obviously they can be used to make a point about the character. "Edgier" characters are more willing to differentiate themselves from other characters, and tattoos and piercings are but one way to do that. The type of tattoo chosen can tell a lot about the character, as well as how the character sees himself. A tribal tattoo shows someone interested in connecting with a primal part of himself while a Celtic tattoo is trying to connect to his ancestors. A henna tattoo may be a temporary addition, but is a good traditional way of adding to one's appearance. Some tattoos show off a person's desire to prove his toughness or patriotism, just as they can demonstrate a person's artistic side.

The tattoos can also define past and/or current affiliations, such as the yakuza does, as well as American servicemen. It can show

gang or tribal membership, something vital for free passage through areas controlled by gangs or tribes. This can also mean instant cred with those groups just as it can mean some restrictions; some Japanese pools forbid those with tattoos. Taking that to an extreme, they can be required in a dystopian atmosphere in order to just do business, such as the Mark of the Beast or a personalized UPC code. They can also demonstrate not beginning to a specific group, such as punks and rebels do.

If you really want to have fun, they can also be used for power. One of those weird cliches you don't see enough of is the tattooed man whose tattoos come to life or have some affect on the character when activated. The exact mechanism doesn't matter, be it magic, nanotech, or even focus-based transmutative abilities, but they can make for some interesting character development, especially if the character has to go on a quest for more tattoos.

If you are looking for a way to add some extra symbolism to your comic, tattoos can work. They also make your illustrator hate you, so use sparingly.

Dressing Women is Harder Than It Looks

One of the major ongoing controversies in comics is the drawing of women. The problem usually breaks down to some variation of objectification especially in the super-hero area. In order to ameliorate this situation it may be interesting to take a look at the reasons that women are usually drawn so that the illustrator can debate the way he draws them, and thus make a better decision on how to draw.

Jochim-Character Building

It should be noted that I'm not saying to not draw women (or even men) this way, just that one should consider how they are drawn in order to avoid controversy.

10) It's just easier to draw a women with minimal clothes.

Given the choice between a muscle structure and clothing folds, most illustrators would prefer the muscles. An arm can defined with a few simple lines, and an entire body can be done in a relative few lines compared to clothing details. For an artist under a tight deadline, the simpler solution is usually best, especially when it saves a lot of time.

9) There's a certain mythic quality to nudity.

Comic books are about legendary characters, and you can't go more legendary than character designs based on the ancient myths. The problem is that they didn't wear a lot of clothes back then, especially when they were active. If you were attending a party or lounging around the toga worked, but not so much in the arena or at the gym. This applies even today, when Olympians wear the minimal clothing for their sport.

8) It is more functional.

Obviously putting a woman in heels for battle is a bad idea, and the most gorgeous dress in the world can be a liability when she is being chased. However, for a character with martial arts who wants to use them a minimal costume works far better than even comfortable clothes. In fact, loose clothes can be a combat liability when fighting someone with large piercing weapons; the clothes can be used to pin the character down. Also, it can slow a character down; just ask Mockingbird (Bobbi Morse) about running through a bramble some time about those huge flaps of fabric. Sure, Spandex has its own problems, but at least it doesn't slow you down.

7) Victorian dress looks great, but it wasn't designed with an active woman in mind.

It may look pretty, but Victorian garb was designed with the idea that good women didn't move much. Also, it was ideal for slowing women down in another way: When you needed another person to dress you couldn't do anything naughty. This all makes Victorian fashion, and a lot of women's fashion for that matter, great to look at but not that great for active women. It also makes it more difficult to draw than a T-shirt and a pair of jeans. Yeah, this is more addressed to those that re-design costumes with a Victorian concept, but I feel it had to be addressed.

6) Women themselves like to dress sexy.

Women put a lot of time and effort into their appearance and they like to be appreciated. This applies double if the woman has been putting serious time at the gym; dressing sexy is part of the fun. This is why women wear tight pants, flowing dresses, and strapless dresses. However, too many people get nervous when a woman shows a little skin; these are people that would die from culture shock if they ever stepped foot in Europe or even at an American beach. This is something worth considering.

5) If it's good for the gander, why not the goose?

It never fails to amuse me that you can have men running around in loincloths, but the second a woman shows up in a bikini feminists scream "SEXIST!" I like my Conan the Barbarian, and part of that means Red Sonja. I know it's a simple argument, but if skimpy clothes work on the men, they should work on the women as well. It's a consistency issue; if the men are wearing comfortable clothes, why should the women be restricted to clothes that are pure bulk? Wouldn't that take away her competitive edge just so someone is comfortable with her

wardrobe? I guess you can dress for the occasion or win, but not both.

4) Dressing how you want is a big part of equality.

I just find it sort of weird that sexual liberation is part of the feminist movement, and I think it would be hard to argue that the Sexual Revolution was overall a bad thing as it was a major assist in some areas of the Civil Rights movement as a whole. In fact, part of the reason fought for equal rights is to get out of the ridiculous fashions that kept them literally constrained. Ironically, however, you have some feminists start screaming "SEXIST!" whenever a woman is pictured in anything less than full winter wear. Seriously confusing when you think about it.

3) And what about the other kind of fun?

Sometimes you just want to parody the whole situation, and that means using a sexy woman who has been exaggerated. We need to be able to make fun of different aspects of the comics industry, as well as other media, and that means that we need to be able to draw them as well. The most notable example of this is that Power Girl (she of the boob window) is used as an example of the problem of how women are dressed in comics, as she's a straight satire of some of comic's...um...bigger issue. Someone apparently needs to get a sense of humor.

2) What about current fashions?

This sort of goes both ways, but I'm looking specifically at the tightness of current fashions. A lot of women wear tight clothes both on the street and in social situations, and that's ignoring the sheer number of bikinis on the beaches and near the pools. I just find it interesting that people want more realistic art in comics but hold illustrators to a Puritanical standard of dress that obviously doesn't exist in real life.

1) Women should be allowed to dress for the situation.

Man in a shower? No problem. Locker room scene of guys after exercise? Cool. Teenage boys changing into fighting uniforms? See it everyday. Guy in bed in nothing but boxers? That's natural. But the second you show a woman hanging around in a loose tank top and shorts, no matter how hot the weather is, and it's obviously an unrealistic portrayal of the woman in question. There are just times when its natural to wear minimal clothing and it would feel weird if the woman in question was wearing a parka.

Obviously I'm a pervert, but I don't think women should be limited to loose bulky clothing. As long as it's not being done for the sake of exploitation then there should be no real problem with how a woman is dressed, especially if she's dressed appropriately for the situation. Just be respectful about how you do it and it should be fine.

Weapon Design 101

One of the fun things about fantasy comics is that you get to design some of the coolest weapons. However, I think I've gotten a little annoyed at the Final Fantasy school of weapon design; I really think that if you are going to design a weapon the phrase "Freudian compensation" should not come to mind. That is, rather than merely design the biggest, baddest weapon on the planet the weapon should be designed to better fit the character. In order to help designers here are my thoughts:

1) Fit the weapon to the character. A sword should not be the default weapon for all characters, even if the series is about swordsmen. Every weapon has a history and an associated symbology associated with it, and you should take full advantage

of that. A scythe, for example, is great for a scary character that you wish to associate with death, just as nunchucks are good for a martial arts character. A more pensive character is more likely to have a ranged weapon, while a more action-based character will have a melee weapon. A character who considers himself an artist will have a more exotic weapon. The Teenage Mutant Ninja Turtles are the best example of this: Noble Leonardo has a katana, scholarly Michaelangelo has a staff, aggressive Raphael has sais, and goofball Donatello has nunchuks. There are weapons associated with peasants (most martial arts weapons), military weapons (spears and pole arms), and even nobles (swords and fans). Take advantage of that to use weapon choice to build the backgrounds your characters.

2) The look of the weapon says a lot about the character. A sword can be a weapon of nobility or savagery, a sword with smooth lines represents a more noble characters than one with barbs. Throw in a blood groove and the character is a sadist. A rusty sword is for someone who hasn't fought in a while, and shiny sword is for the novice. A fancy hilt is a show off, while a bit of gold makes for a rich character. And that ignores any symbols on the weapon itself, such as waves, runes, or even no decoration at all when everyone else has symbols all over their gear. All of these little details can tell a lot about the character who wields the weapon.

3) How the weapon is carried is important. A character who is sneaky and should not be trusted carries weapons that are small or are easily hidden. An upfront character has obvious weaponry, and usually no more than one or two. A well-prepared character usually carries several weapons. A character more interested in comfort may carry his weapons more as an accessory while a battle-ready character ties them down in easy-to-access locations.

4) The weapon doesn't need to fit the character as long as it shows something about the character. The obvious example is the young character who is wielding his dead father's weapons; he needs to grow into them over time. Another fighter may be wielding the weapon of his ex-lover that he still loves, while a group of soldiers may wield the same blade in order to show solidarity. If the character is wielding a weapon that obviously doesn't fit him you need to have a reason, and that makes for some interesting stories in and of itself.

When it comes down to it, a weapon is a major investment in the character's time and energy. Even if he inherits or is assigned it, he needs to train with it, learn its intricacies, and be able to defend himself with it. It makes sense that it tells a lot about the character given that it will easily be one of the biggest trademarks about the character. It's also a great way to get into the character as a writer as you need to worry about why he's carrying it. So put some serious thought into what kind of weapon he wields, and what it means to him, and the character can only benefit.

Note: Yes, all of these points apply to all of a character's equipment. You want to debate applying that to all of the character's armor, clothing, and sundry jewelry and equipment, but a few pieces definitely works.

There is no such thing as a minor detail when it comes to your characters. Your readers will debate every little detail and what it means. Keep that in mind: Everything your characters say, everything they do, and everything they wear is up to scrutiny.

That can be irritating, sure, but it can also give you a chance to have some serious fun.

IN CONCLUSION

All of these tips and tricks should make it far easier for you to write characters, as well as allow you to make it easier on the illustrator. The entire point of this is to give you things to think about when you start writing and possibly to make you stay awake late at night wondering if you have done all that you can. You do not need to use everything that you see here, but I hope that you found something worth using and that could help you.

If you like what you've read here, check out my Mixing Art and Business blog (https://twosparrows.blogspot.com/) and my podcast, Webcomics Reviews and Interviews on iHeartRadio (https://www.iheart.com/podcast/209-wcri-29938422/). You can also buy the How To Create A Comic Workbook (http://www.indyplanet.us/comics/86921/) which allows you to create a bible for your comic or other literary work. If you enjoyed this please a review!

Thanks, and happy creating!

Final Secret: Write the characters you want, not the ones that others want. It's ultimately your story so make sure that the people you populate it with are people you want to share the journey with you.

www.ingramcontent.com/pod-product-compliance
Lightning Source LLC
Chambersburg PA
CBHW030017190526
45157CB00016B/3024